PROVINCETOWN III

THROUGH TIME

FRANK MUZZY

AMERICA
THROUGH TIME®
ADDING COLOR TO AMERICAN HISTORY

America Through Time is an imprint of Fonthill·Media LLC
www.through-time.com
office@through-time.com

Published by Arcadia Publishing by arrangement with Fonthill Media LLC
For all general information, please contact Arcadia Publishing:
Telephone: 843-853-2070
Fax: 843-853-0044
E-mail: sales@arcadiapublishing.com
For customer service and orders:
Toll-Free 1-888-313-2665

www.arcadiapublishing.com

First published 2018

Copyright © Frank Muzzy 2018

ISBN 978-1-63500-068-9

Typeset in Mrs Eaves XL Serif Narrow
Printed and bound in England

INTRODUCTION

Provincetown Through Time III is the ongoing tales first introduced in the top selling *Provincetown Through Time* and *Provincetown Through Time II*—ever popular with locals and visitors alike. Its comparison views, with collective imagery, reinforces the point that "a yellowed photo is a captured memory of those long gone." These memories illuminate and tell the history of Provincetown and provide a clearer idea on where one is in that timeline of this truly most interesting "town."

Vikings, dating from 1004, dubbed the spit of land as the "Cape of the Cross", which they believed to be the sacred burial ground of Thorwald, brother of Leif Erikson. But it is its American history that is like no other; beginning in the seventeenth century, it has evolved through its five-century continuum. Yes... pride speaking: celebrating its 400th year, and although sometimes overlooked by historians, Provincetown was where the Pilgrims made the

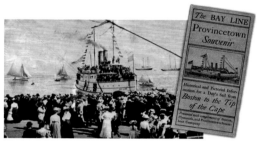

"The Cape Cod," on the Bay Line, RR Wharf, *c.* 1902."

first landing, before traveling on to that "Rock" they're always talking about. It was in Provincetown Harbor that the Mayflower Compact was drawn up and signed, establishing a government with binding laws, considered to be the forerunner of the Constitution. During the eighteenth century, Provincetown would be the largest whaling port in the country, and in the latter half, the British would use its deep harbor for naval fleet staging during the American Revolution. The nineteenth century would see the raise of the cod industry as the whaling trade diminished, and by 1899, P'town would become the largest artist community in the world, contributing both important art and literature to the twentieth century, accounting for more Pulitzer Prizes per its 9.7 square miles than anywhere else—the writings of Eugene O'Neill, Michael Cunningham, and the poetry of Mary Oliver topping the list. The Provincetown Art Association and Museum has a proud roster of artists, from Charles Hawthorne and Henry Hensche to Hans Hoffman and Jackson Pollock, with the town's distinctive lighting providing the catalyst for many of these works and still attracting the artists of today. Its renowned Friday night gallery walk, a tradition not to be missed, exhibits well-known and upcoming artist names of the twenty-first century.

Provincetown's uniqueness has always predestined the most interesting array of townies and wash-a-shores, from Henry David Thoreau, Mary Horton Vorse, and F. Scott Fitzgerald to Norman Mailer, Marlon Brando, and Tennessee Williams. The town is home to several cultural icons, such as Alice Brock, famed from the Woody Guthrie's song and her cookbook—♪ *You can get anything you want, at Alice's Restaurant*♪—as well as film maker John Waters biking down Commercial. Also a-trundling

about is Lip-Schtick, whose multitude of costume changes gives Miss Richfield 1981 in her motor car a friendly run for her money. And "Breaking News," while the politics of Rachel Maddow may retreat to the West End and commentary of Andrew Sullivan finds peace on the East End, both pay homage to local mariner Admiral MacMillian, famed North Pole explorer with the wharf named for him.

And with or without a "sea serpent", P'town is "Party Town"; just as it had been for the pirates (who called it "Hell Town") in the 1700s. Every year, the season begins with the internationally recognized Provincetown Film Festival and progresses with the blessing of the Portuguese fishing fleet; however, it seems to hit its stride by July 4 and Bear Week, winding up with a P'town take on Mardi Gras, "Carnival," and its over-the-top spectacle parade of creativity and humor. Its nightclubs come alive and an evening stroll down Commercial Street is like the "Barbary Coast" of the 1880s, but with today's top-notch entertainment. Its dance bars are full of the joyful abandon of carefree cavorters, a mix of tourists and townies revved up from a "boat-slip" afternoon "tea."

Provincetown Through Time III is a photo-essay time-tale of its main intersection at Rail Road Crossing, Commercial, and Standish, from horse-drawn carriages of the nineteenth-century, the horseless carriages of twentieth century, to the bike-barrage of the twenty-first century. P'town's population grows from 3,000 off season to 70,000-plus, all with more adventurous tales to tell. It is a gallery walk featuring artist centenarian Ilona Royce Smithkin—"a redhead on the town"—fluttering her self-designed 3-inch red eyelashes with memories of her own gallery of the 1960s; it is also a visit to the famed eccentric painted furniture of Peter Hunt Village.

Provincetown Through Time III is a stroll down some of the residential side streets, showcasing home-lore, including the "figurehead" found floating in the Indian Ocean (now a home-affixed masthead, a watchful eye for her ship to come in) and the West End home as a stop on the "Underground Railroad" for those escaping slavery. It is also the train station saga mid-town, switching from "Ol' Engine 99" to the "Oldsmobile 88" and fears of future development's diminished charms. It is the Shank Painter ice ponds, providing dairy farmers the ice for their products throughout the year. It also recounts the prohibition tales and townies at the

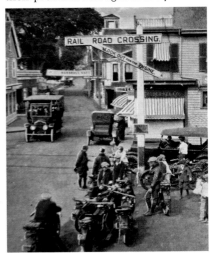

Rail Road Crossing, Commercial and Standish, 1925, as a tourist accommodation bus approaches.

shoreline, fishing out liquor cargo from shipwrecked rum runners and the ill-fated sub in the harbor, submerged when accidently rammed by a coastguard ship patrolling for those illicit boats. It is the laying of pipes in 1905 on Bradford by imported prisoners and the local primo pipe-laying and repaving of 2017. It is the burning down of Whaler's Wharf, the Provincetown Theatre, and the Crown and Anchor in 1998, with fears that the whole town would go up in the flames, save for the firefighters fighting that battle so honored in parades and the "Fireman's Ball."

With a rich history from the Pilgrims to the Portuguese; through the artists and the tourists, Provincetown has a distinctive effect on all that come here. Phenomenally, it is still a quaint little New England seaside fishing village!

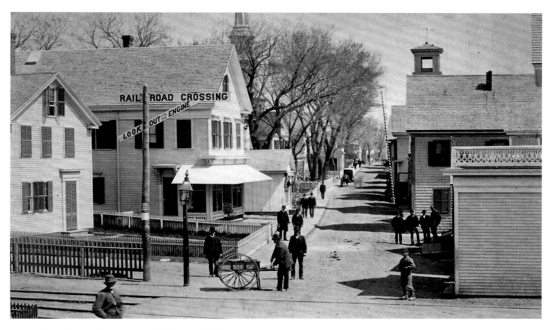

RAIL ROAD CROSSING 1879 AND 1900: On the right corner of Commercial Street and the Standish alleyway, just across from Sarah Small's picket-fenced yard, is where the region's post office was located and where everyone retrieved their gossip with the mail. Al Small had his tailoring business (broad awning) right next door from Sarah's yard and on the other side was the little barber shack of Joe Francis. The intersection was also where the rail line would cross Commercial Street as it extended to the end of that pier for the fishing fleet's cod catch. Below, the post office would become a billiard parlor by 1900 and Standish with a stronger fence more accommodating to horse and buggy; local P'towner Si Young is seen here making the turn with his horse and "Jigger" long before he had his own antique store further down Commercial.

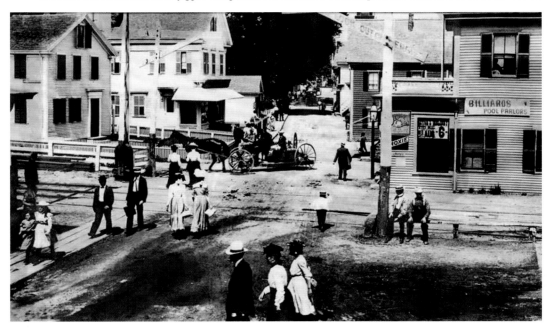

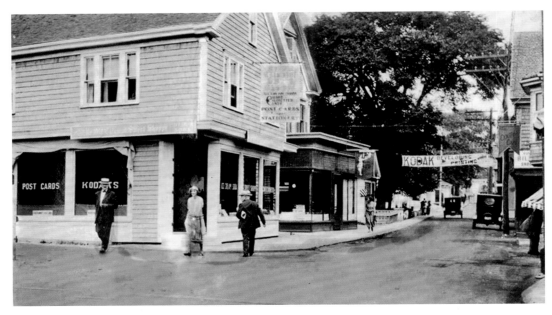

RAIL ROAD CROSSING 1925 AND 1962: As more tourism arrived, so did the mix of local services, inn lodgings, restaurants, and sightseeing. The front yard of Sarah Small, on the left, was built on by 1915 as a store front, first as a souvenir & postcard shop then as the "First National Grocery Store." The stripped awning far right became the A&P market in the late 1930s. Standish is a full fledge street sharing space with the train track, but by 1960, as telephone and electrical wires increase, the train tracks are gone, commercial use of RR Wharf ends, and the wharf is deeded over to the town, soon to be renamed McMillian Pier after the P'town local mariner and North Pole explorer. The Governor Bradford Inn took over the store and would expand to Al Small's tailor shop to add its famed entertainment bar and restaurant.

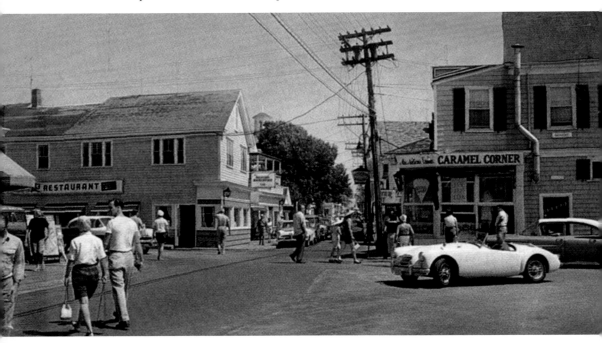

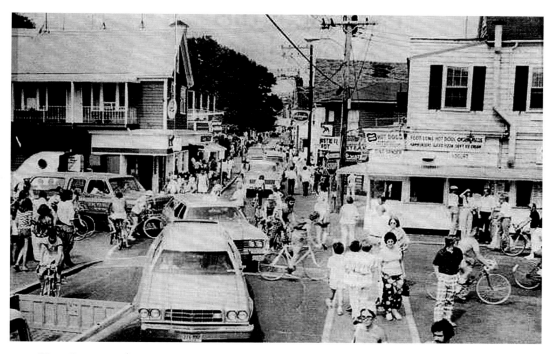

YIKS BIKES: Rail Road Crossing 1976 and Today: Commercial Street and Standish by 1976 and the intersection becomes the tourist barometer on the crowds in town. The Governor Bradford Inn has added balcony entrances to their rooms and there seems to be an upswing in the biking population amongst the parade of family-filled station-wagons (the SUVs of 1976), making the children's nursery rhyme seems apropos: 🎼 "Railroad Crossing lookout for the cars, can you spell that without any 'Rs'?

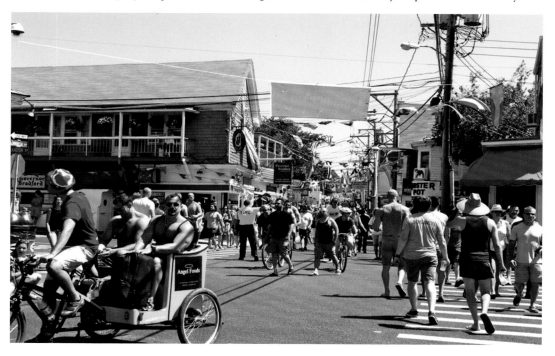

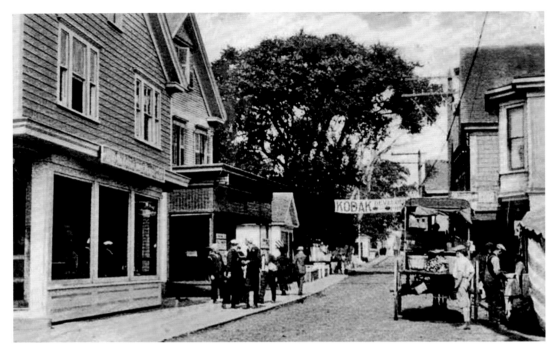

LOBSTER POT WAGON: A 1915 image looking east from RR Crossing as a group of sailors hit port and looking for a good time. It would be about the time the Governor Bradford would take over the two store fronts the sailors are passing, adding a balcony as below. But perhaps the "seadogs" are distracted by the wagon full of lobsters and clams in front of the small house; what a great place for a lobster restaurant—"let's start a franchise!"

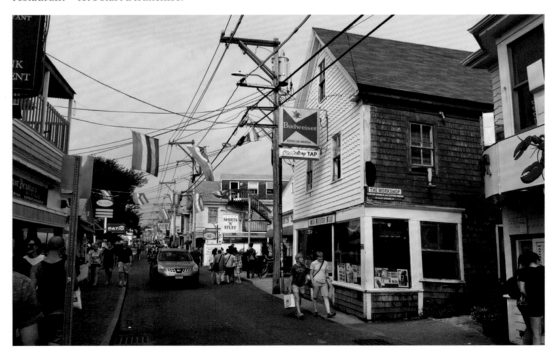

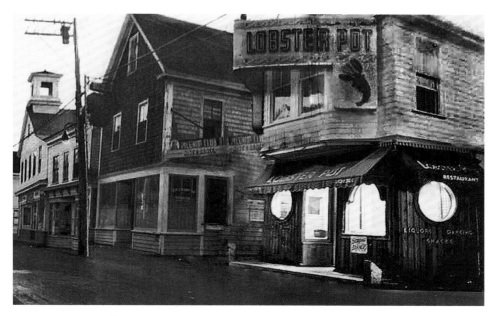

THE LOBSTER POT: Commercial Street *c.* 1948 and the Lobster Pot with its port-hole windows back when they offered music and dancing with your "direct from the tank" lobster choice. Today, no room for dancing, but customer Rolando Vasquez manages a selection from the tank. (Do not give your crustaceous choice a pet name!) The alleyway right next door was the entry to the Pilgrim Club Inn, offering its backroom dance bar, a.k.a. the "Rumpus Room", to locals and a few sailors alike until it was closed by fire. On the far left was the last building (a former schoolhouse) to have been floated over from Long Point eighty years before—also soon to be lost to fire. Below: the inset shows off the Lobster Pot's beacon of neon.

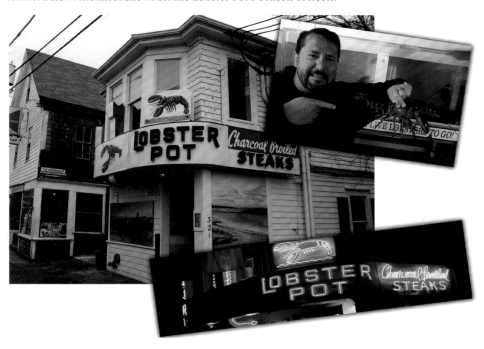

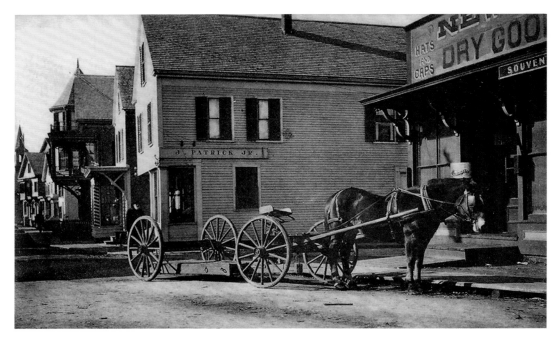

JAMMED WITH JIGGERS: Horse & jigger wagon is parked and awaiting the driver in front of the New York Dry Goods store at Rail Road Crossing in 1893. The store was so named as it was situated across from the "New York, New Haven, and Hartford Railroad" line that owned the Railroad Wharf for commercial loading (eight to ten RR cars daily). The "Jiggers," seen everywhere in Provincetown, with their low loading beds designed primary for hauling heavy loads, were perfect for the barrels of cod from the fishing fleet to the rail line for shipping and occasionally as a great conveyance for transport of lobster traps. Below: it is the T'bird awaiting its driver!

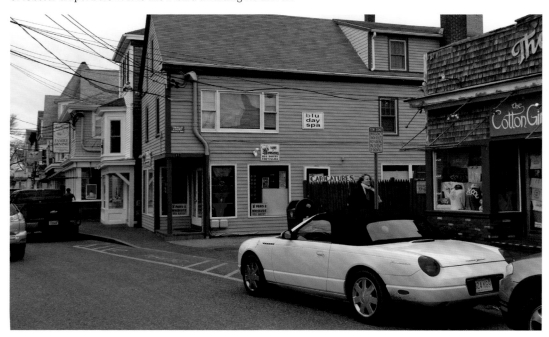

BEARD TRIMMING AT JOES: Mr. Cook, a Provincetown Selectman, may have been thinking of having his beard trimmed by Joe Francis at his little barber shop on Commercial Street *c.* 1890. Perhaps he's negotiating the snow to cross to "Matherson's Clothing" or up the stairs to Hubert Engel, town tinsmith. At any rate, today, instead of the beard trimming, it would be all about wiping from the whiskers the great yogurt from that same little shop, or crossing Commercial Street to exchange his overcoat for "Tee Shirts and Stuff."

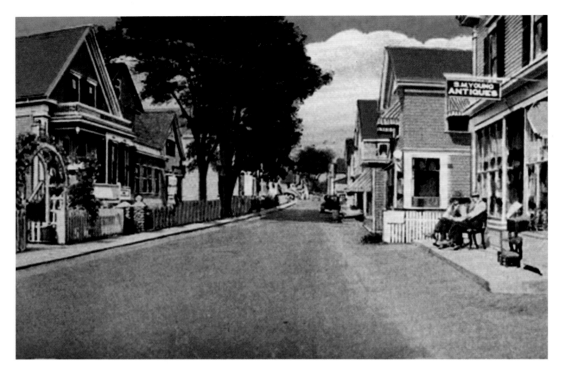

ANTIQUES AND THE BENCH 1: A 1939 Postal card of Mr. Si Young who often could be found holding court—greeting neighbors as they passed his antique store. Most of the houses here have been converted to shops and S. M. Young Antiques is now the place to find "hip" trends in furnishings and art at "Room 68."

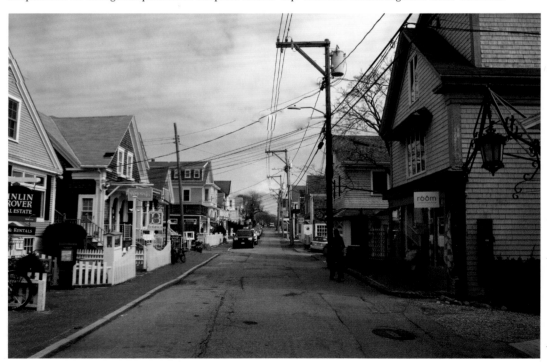

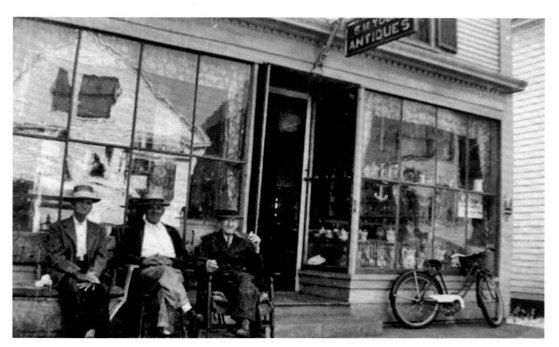

ANTIQUES AND THE BENCH 2: Like the post card image on the opposite page, but it's a candid "reality" snapshot a few years later in 1943; Si Young retiring to his rocker and still "chumming" with his neighborhood pals. Si was quite well-known about town prior to his antique shop, not because of any football award, but because he was often seen commercial hauling in his horse and jigger (since 1900) or "hauling" tourists in his horse drawn "barge" (early term for taxi). As for the stylized post card images, they often showed a more scrubbed depiction but were a fond remembrance of Provincetown to be mailed all over the world or pasted in numerous scrapbooks of vacation memories. Today, the antique shop as "Room 68" is still a gathering place, sponsoring open houses for their latest arrivals in fine modern furniture.

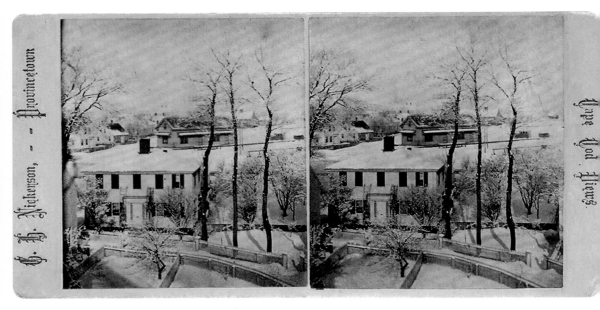

FREEMAN FOOT PATH AND NICKERSON'S STEREO-OPTICS: There were several foot paths or lanes that one could take between Commercial Street and Bradford. This one ended at the train station seen in the center of the 1873 image. The perspectives are from the top floor window of what Nathan Freeman built and donated: the town's first library, with the third floor as artist spaces. Local photographer George C. Nickerson was the first to occupy a studio, and the above snowy image is from Nickerson's stereo-optic "Cape Cod Views"; a stereo viewer device would give collectors a 3-D effect. Although obscured by trees and decades of questionable additions and remodels, the house along the lane, now Freeman Street, remains.

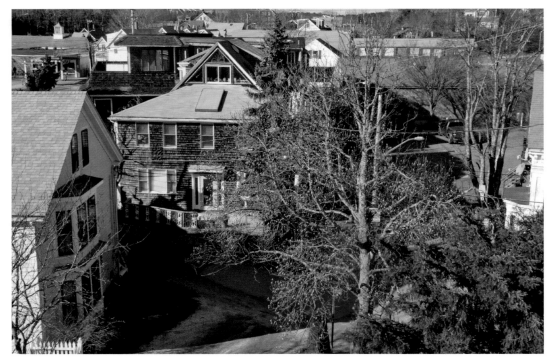

FREEMAN'S "S" CURVE: Behind the old Freeman house, now the Provincetown Visitor's Center, is the well-known and well-worn lane that was an "S" curve shortcut from Commercial Street to Bradford, a.k.a. "Back Street," heading the train station. But to the image to the right, back in the late 1800s, it seems to be the perfect place for "Back Street gossip". Locals today use it as the well-worn shortcut from Commercial Street to Napi's Restaurant, built with his own two hands. (Not to be missed is Napi's private art collection.)

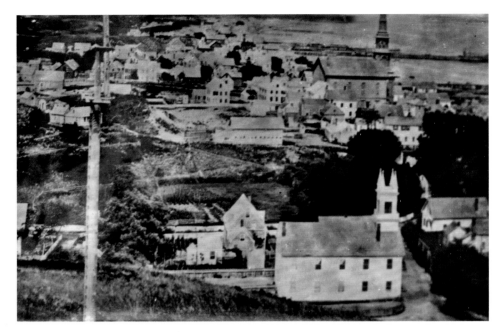

POLE PERSPECTIVE: Bradford Street ended here, continuing as a narrow dirt road at the Center School, one of three main primary schools all having served P'town since 1844. The 1866 photo advantage is from High Pole Hill, a name earned from the signals, flagpoles, and other devices seen on the left, placed on high, operated by the U.S. Weather Bureau, displaying wind and watercraft warnings using flags and lights. Within the next decade, rail service and a railyard would enter the picture at center and with it a widening of Bradford further east. Below, the growth is obvious except the railyard, as well as the school, are now parking lots. (Note: upper right, the church steeple (today's library) has a lower profile—lost to weather.)

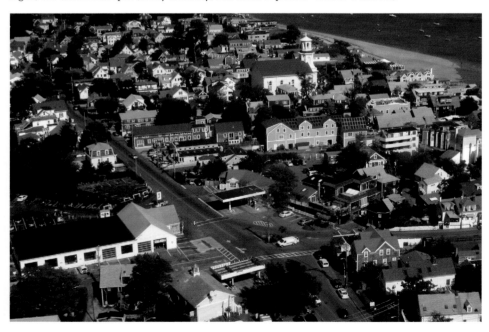

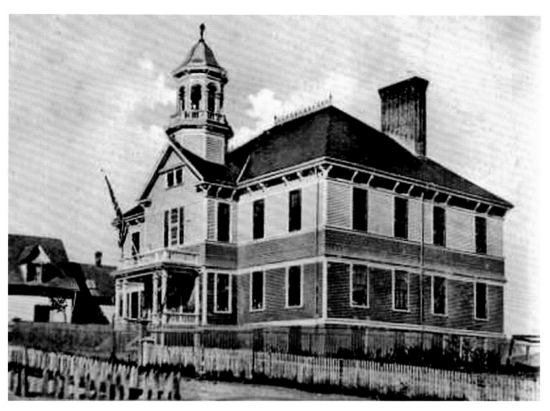

GOVERNOR BRADFORD SCHOOL: Built in 1892, the Queen Anne-style structure was quite the pride of the community until the night sky was set aglow with its destructive fire of 1935. Below: a Colonial-Revival replacement, which served until 1956 and is now a community arts center.

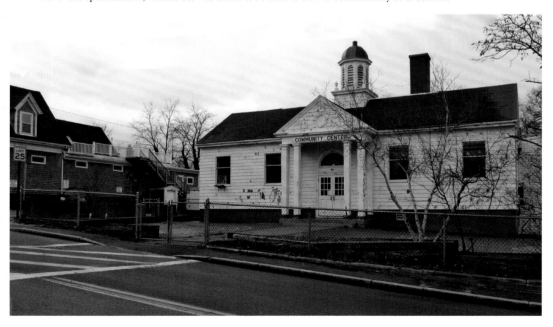

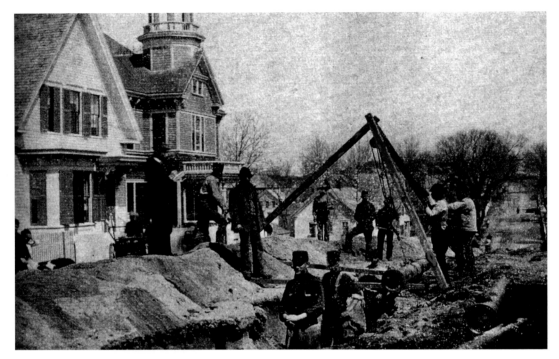

PRISONER PLUMBERS: Prisoners from Barnstable House of Correction laying pipes along Bradford Street in front of the Governor Bradford School in the fall of 1905. Below, the house to the left (now for commercial use) provides bikes for the community. The inset contrasts how it's done over a century later, with pipes that are being laid by "pipe" professionals over on Commercial Street.

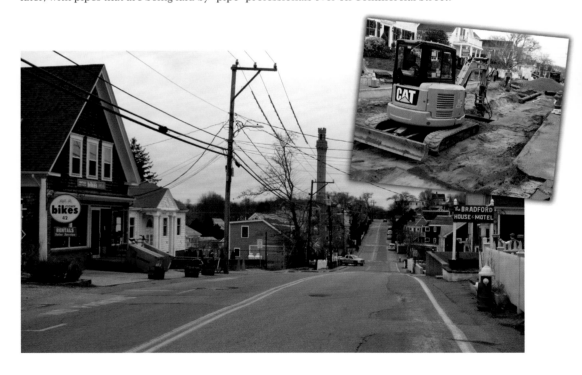

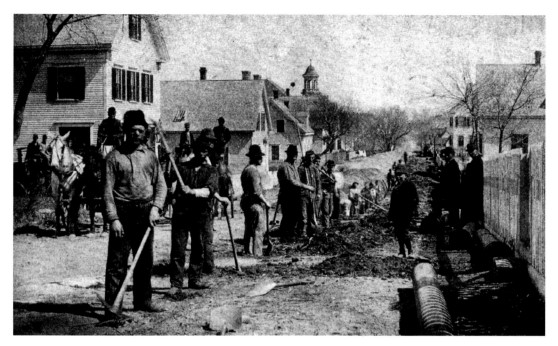

BRADFORD 'S BARNSTABLE BOYS: Correction continuing with the widening and repair of Bradford Street in the fall of 1905, at Montello, correcting in this case the narrow dirt road, widened for more horse traffic. Today, Provincetown hires the professional "crack crew" of Robert B. Ours Construction, seen here posing while on break for this photo as they lay pipe and repave Commercial St.

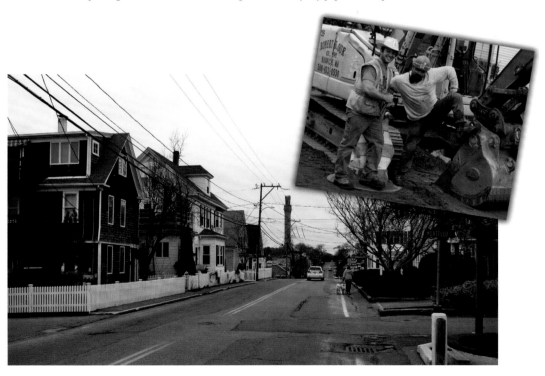

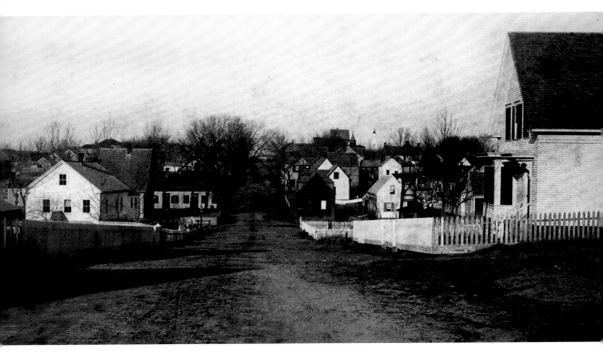

LOOKIN' FOR ICE CUBES: Bradford Street (further east) to Shank Painter in the late 1800s: the old town hall atop the hill is gone, yet to be replaced by the Pilgrim's Monument, and the new town hall has just been built—note the clock tower and church steeple just to the right on the horizon. On the left, before the rise in Bradford, is the Shank Painter Path, just wide enough for the dairy farmer's wagons to head out to the "ice ponds."

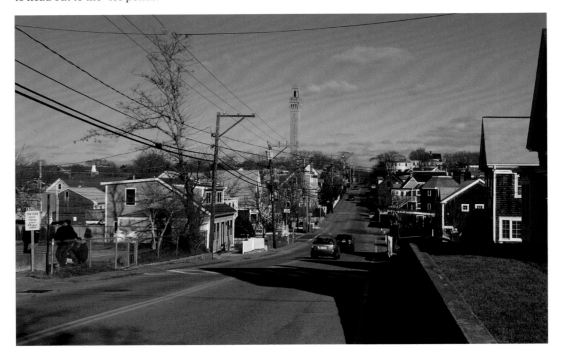

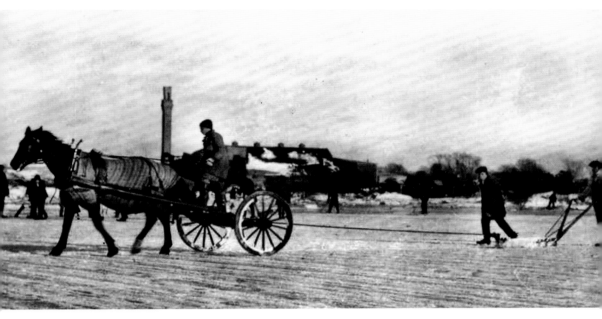

ICE HARVESTING: During the winter on the frozen Shank Painter ponds, the ice blocks would be harvested by dairy farmers, hauled back to the farms, and stored in wooden sheds heavily insulated with hay and sawdust to be available and last through the summer months; this was done to keep their milk and other dairy products from spoiling whenever shipped to city markets. Rule of thumb: a half-ton of ice per cow. (*Image from the Ross Moffett glass plate photo collection and taken next to what is today's fire station*) Refrigeration may have been developed in 1805, but this system would last out the century and into the early twentieth. Today, many of the ponds, iced over or not, are natural habitats for birds and pastoral settings for backyards.

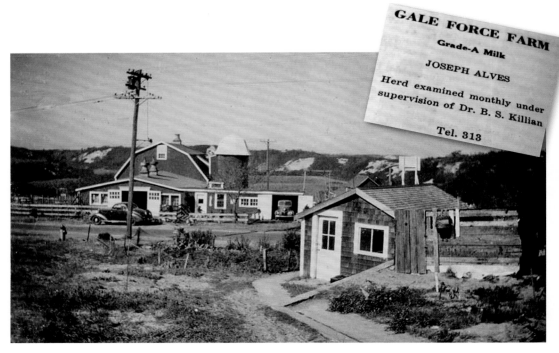

ONE OF THE DAIRY FARMS: Since the late 1800s, Guernsey and Holstein cows wandered in the pastures behind the Gale Force Farms (seen above from the farmhouse in 1934). The Bradford Street extension divided the farm some years back, but as one of five dairy farms around Provincetown, it outlasted all the others, finally closing in 1952. The ad inset also posts the Provincetown three-digit operated assisted phone number. Today, the name "Gale Force" is honored as "Gale Force Bikes," a great place to rent a bike, and the farmhouse still there retains its hilltop site. And direct dialing has now been mastered!

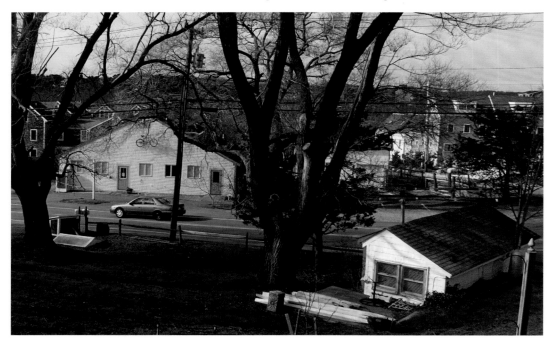

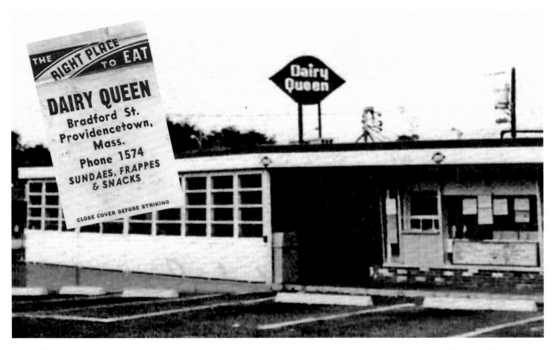

LACTOSE TOLERANT: Near "Gale Force" was the Dairy Queen on the corner of Bradford and West Vine catching beach traffic. (*Image courtesy of "My Grandfather's Provincetown" blog*) Aside from Commercial Street's "Burger Queen," some might say with tongue in cheek that the town has "Queens" on every corner. On that same Bradford–West Vine corner today is the ever popular Victor's, for fine dining, drinks, and delightful conversation.

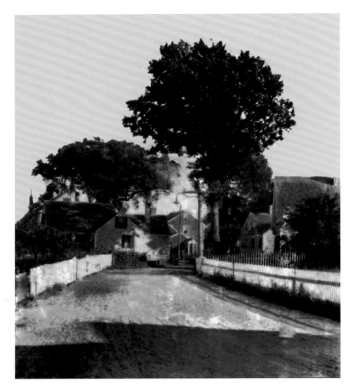

ATLANTIC AVENUE PICKET FENCES: By 1915, the path with the "S" curve down to the shore had been widened and Atlantic Avenue began to fill in with Clapboard houses and picket fences. In some cases, the picket fences seemingly came first. Today, as all the lots have been filled in, one must remember: if you think you can find parking on Atlantic, you can't!

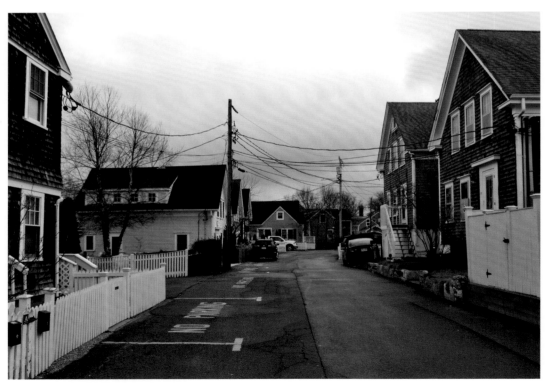

ATLANTIC AVENUE WICKED SENSES:
Wandering further down Atlantic, after
the "S" curve, it narrows to just wide
enough for a single-direction horse and
buggy, evidenced by the ruts leading to
Commercial. Foot traffic crossing here at
Commercial would continue down to the
beach access. Just a block-long Atlantic
served the dozen houses and made the
connection from Bradford. Today, trekking
down to the water's edge, it's the lore of
the famed "Dick Dock" that tells of other
connections being made.

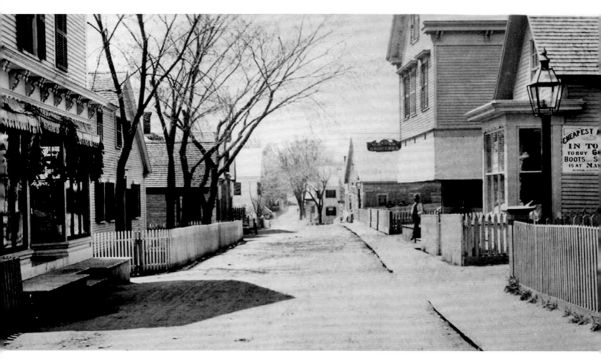

MAYO'S BEST BOOTS IN TOWN: If shopping in the vicinity of Conant & Commercial Streets before 1885, stop in at corner shop of Mayo's, proud of their "Cheapest Place in Town to buy Good Boots and Shoes" signage. Next door with the oversized shade awning is the West End, "M. Brown's Groceries", just one of several neighborhood markets.

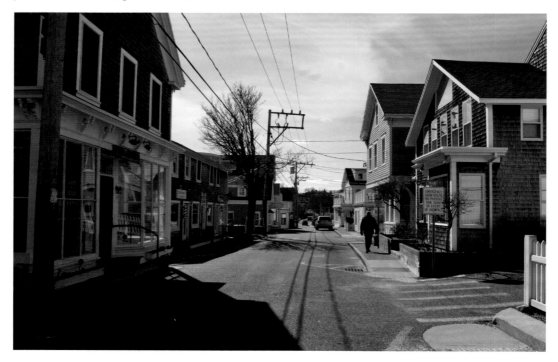

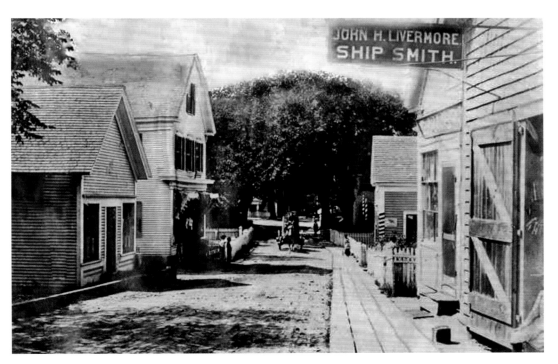

PLEASANT LOOK WEST TO CHIP HILL: Just before the turn on Commercial *c*. 1890, several children dot the neighborhood as family businesses, such as "John H. Livermore Ship Smith" at the corner of Pleasant Street and Commercial, catered the building and repair of the many fishing boats out in the harbor. Hence, beyond the turn up on Tremont, it became known as "Chip Hill" for all the boat wood workings.

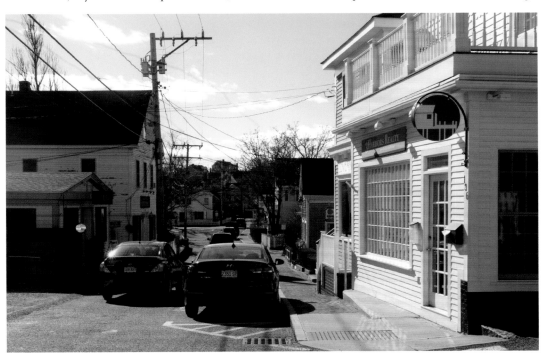

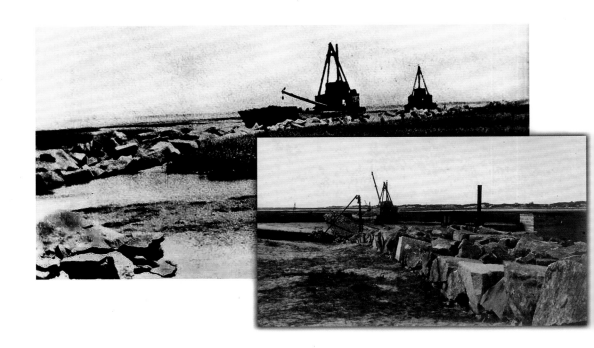

BREAKWATER CONSTRUCTION: Ross Moffett's glass plate images from 1911 of the construction, rock by rock, of the breakwater at "Pilgrim's Landing" about where the *Mayflower* first landed. Below, "rock-hoppers" used to make their way out to the light house at "Wood's End" and back, tide willing of course. This was not always possible, with this 1930s postal card revealing one of three or four breaks in the barrier.

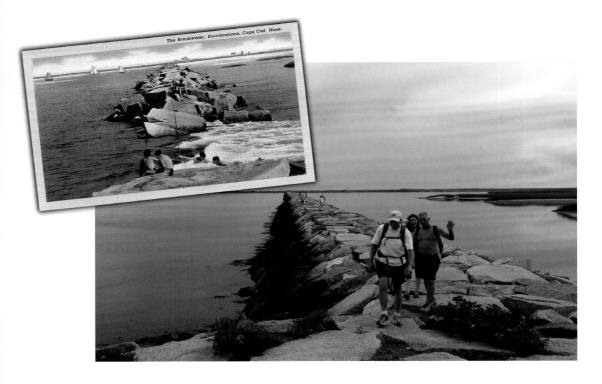

The Breakwater, Provincetown, Cape Cod, Mass.

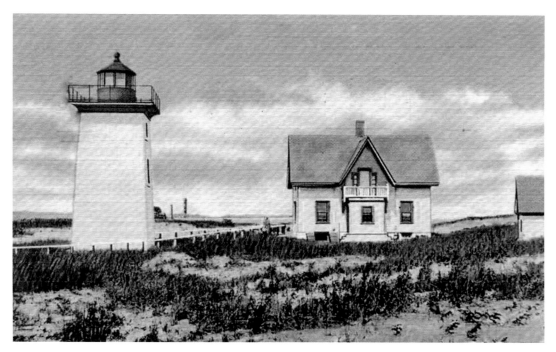

WOODS END: The forest out at Long Point was utilized, along with salvage from shipwrecks, when building the whaling settlement there in 1818. Quite appropriate for a seafaring village, the houses were eventually floated over (the last being in 1867) to join the rest of the town, leaving the lighthouse to provide photo-ops for hardy hikers. Seen above, a second lighthouse, built in 1872, was dubbed "Wood's End," where the woods ended. When the Pilgrims arrived, trees grew all the way to the water's edge, but the land was judged too desolate for settling. Searching across the bay, they found an abandoned Indian village that came with a rock.

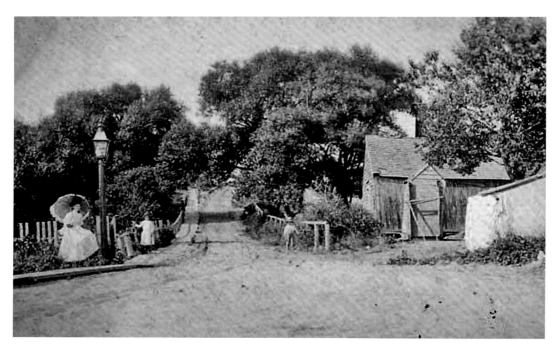

ILLUMINATING FASHION IN P'TOWN c. 1880s: A young woman in white lace and a parasol on a summer stroll near one of the new West End streetlights that bring the innovation of illumination. A movement to light Provincetown began in 1855 with sold shares in a purposeful company for this progressive town. The first streetlights (oil lamps) April 12, 1884 that included the outskirts of Provincetown (above) for a few of the houses and the needed safety of roaming sheep and cows from carriages. (*Photo by John Smith who noted that the Red Inn was just behind the shed on the right*)

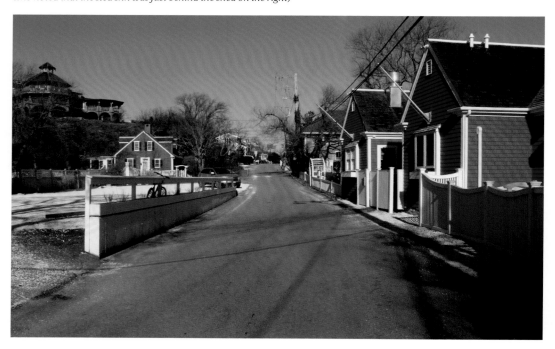

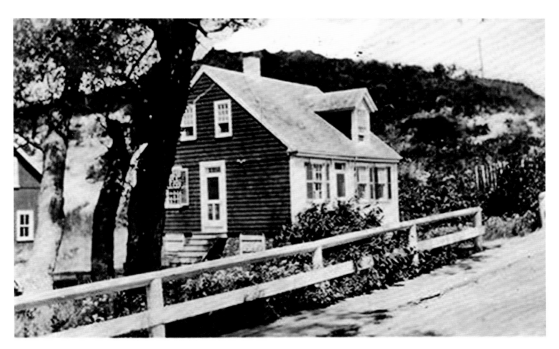

OLD RED INN: The little nineteenth-century red house out near Pilgrim's Landing, often called the original Red Inn, had been the bake shop at Long Point floated over in 1860. Joining few structures as neighbors, mostly farm and grazing land, it was situated across Commercial Street from a house that had been built in 1805, but not until 1915 would *it* become *the* "Red Inn" (see *Provincetown Through Time II*, p. 49) taking that moniker to its celebrated status. And the little red house is now surrounded by wonderful seaside homes and the "Land's End Inn."

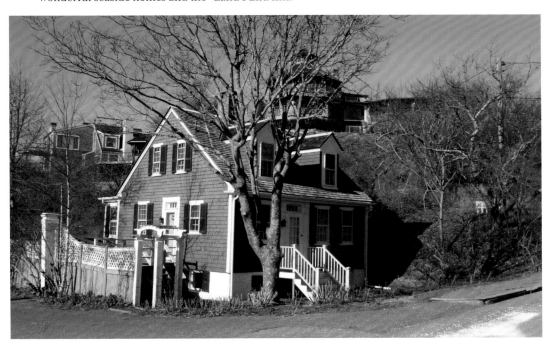

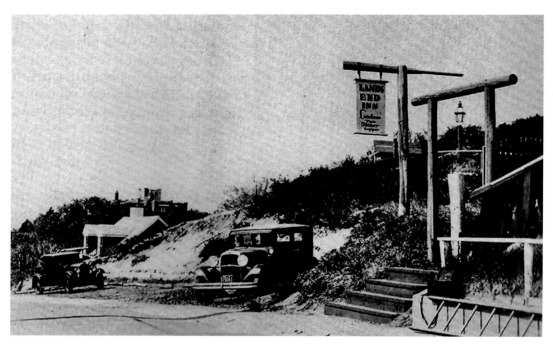

LAND'S END INN: Parking for guests stopping at the "Land's End Inn" in 1932. The Inn had been built by Charles Lothrop Higgins in 1904 as his home and was formerly known as "Higgins' Bungalow." Its 5 acres originally included the beach front across Commercial, but it only settles now on the commanding views atop "Gull Hill"; the views for Mr. Higgins included the castle way in the background! Up the stairs to the right are the twenty-four decorated rooms, which reflected his interests in being a world traveler. A future west wing would be added.

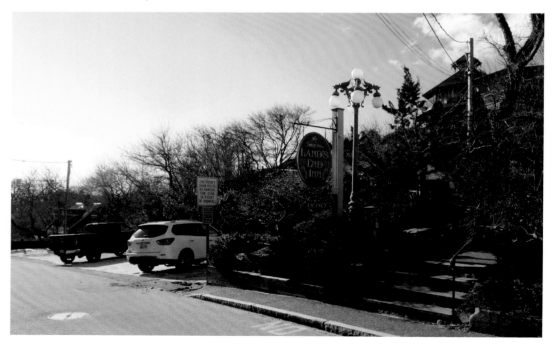

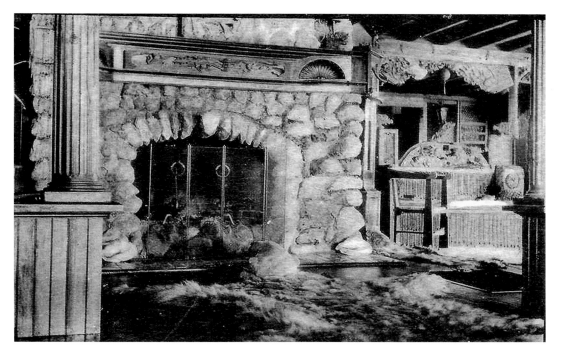

LAND'S END: Inside, the bear-skin rug was where one might snuggle by a roaring fire on a stormy night, just as Mr. Higgins, an entertaining bachelor, might have done. Regardless of the encroachments outside, time has indeed stood still; six years after his death in 1926, his home was developed as "Land's End Tea House" with several name changes in the future, but few changes of Higgins' world. Today, guests who stay can enjoy a "happy hour" around a fire, continuing his tradition.

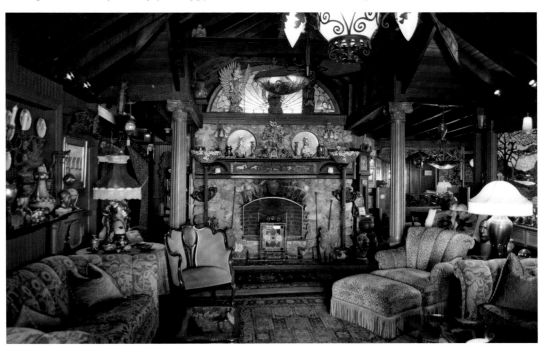

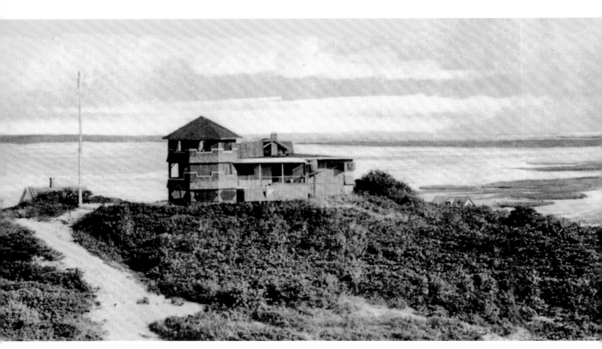

LAND'S END INN *c*. 1900: Commanding the hill as well as the views, Higgins enjoyed it all, with interiors that spoke to his artistic and eclectic nature. He built the craft-laden home with pride as close as he could to where his Pilgrim ancestor (baby Peregrine White) landed in 1620; Peregrine was delivered on the *Mayflower* in the harbor, and was the first white native to be born in North America. Below: the house does not command the hill as much as before, but relaxing in oversize veranda chairs, looking out at the sea, time seemingly stands still.

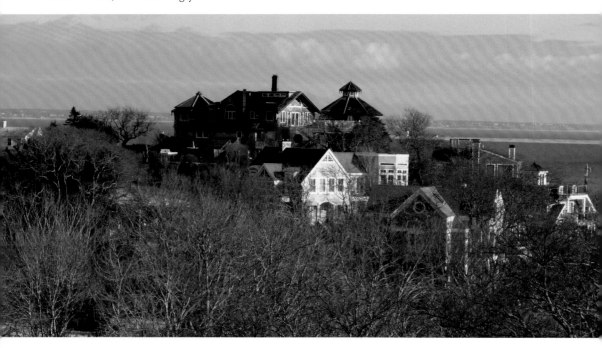

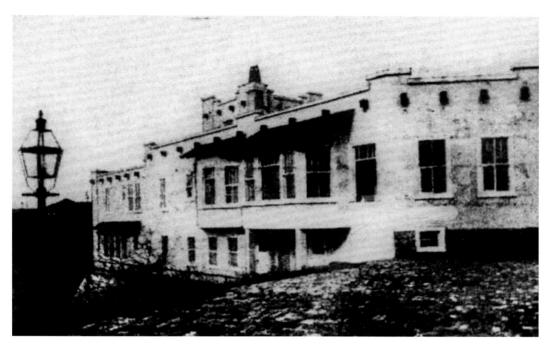

A Modern Architectural Replacement of a Castle: The neighboring home, built in 1911, seen in the distance of so many images, was known as "Duneridge," or "the Castle." It was bought in the 1930s by the founder and publisher of the Journal of Psychology, Carl Murchison; sadly, on May 1, 1956, this home was destroyed by fire. Murchison replaced it with one of the few homes designed by Walter Gropius, pioneer of the glass curtain wall, and the founder of the Bauhaus modern design. Known for larger public project, such as the Pan Am Building, now the Met Life in New York, Gropius design is truly a remarkable tribute to his craft as well as its owners, Mr. and Mrs. Murchison.

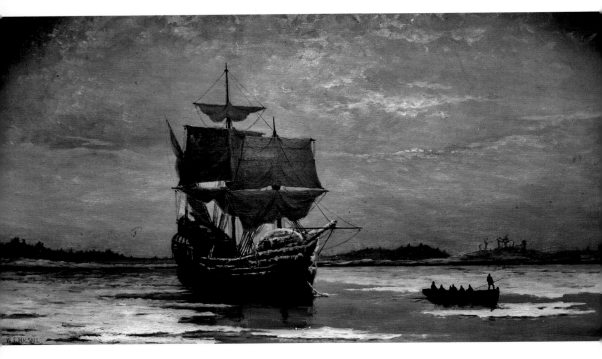

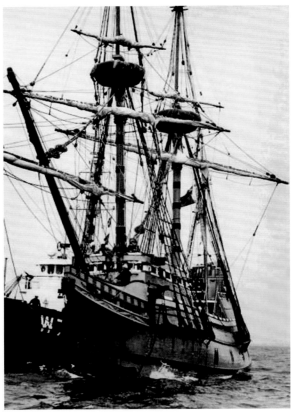

THE *MAYFLOWER*: Above: the artist Halsall William Formby's (1841–1919) *Mayflower* painting, showing the arrival in to the new world. To the left, the *Mayflower II* can be seen arriving in 1957 in P'town Harbor—a glass plate image by noted artist Ross Moffett. Provincetown was the first landing of the Pilgrims. Ship's log: 102 "voyagers" made up of strangers and saints. Forty-one of them, referred to as saints, were Puritans looking for separation from the Church of England. They were quite sanctimonious and annoyingly imposed a minority rule to the strangers, made up of tradesmen, craftsmen, laborers, indentured servants, and young orphans. Leaving their "first landing" a month later, the Pilgrims still retained the fishing rights for years to the seasonal fishing around Provincetown, 5 shillings for all non-Puritans. The harbor is also where the Mayflower Compact in Provincetown Harbor would be drawn up and signed, establishing a government with binding laws, the forerunner of the Constitution (November 21, 1620).

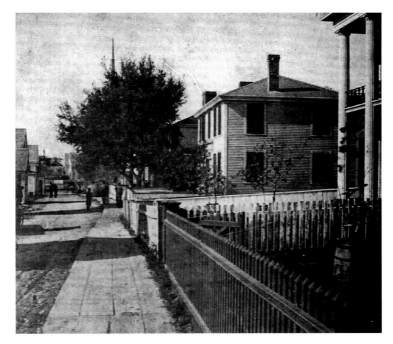

STRANGERS AND SAINTS: The wooden sidewalk and picket-fenced yards in the late 1800s; on the extreme right "The Southern Mansion," built by a whaling captain as his home, *c.* 1840s; it perhaps now harbors ghostly tales as one of his daughters would be born, never marry, and live her ninety years there. Beyond the early 1940s, it served as both restaurants and briefly an art gallery. More recently as "Strangers and Saints," the ol' plantation has been brought into the twenty-first century with fine dining for their fine guests. The Strangers and Saints name derived from those who arrived on the *Mayflower*, but one never feels like a stranger once being served at its beautiful bar.

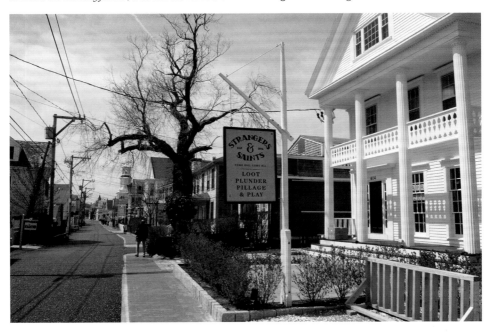

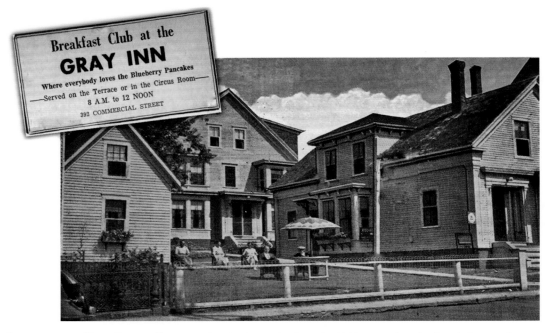

Breakfast Club at the
GRAY INN
Where everybody loves the Blueberry Pancakes
—Served on the Terrace or in the Circus Room—
8 A.M. to 12 NOON
392 COMMERCIAL STREET

LAVENDER TO GRAY INN TO SPINDLER'S: The house built in the 1860s served as the family home of two seafaring captains named "Lavender" until the 1930s, when it became the Gray Inn, *c*. 1938—where apparently everyone loves blueberry pancakes. There were further owner and name changes over the years, The Ocean Inn, the Commons, and now the Waterford Inn. The first restaurant "fronting" across the Inn lawn was built in the 1970s. Today, while these passing gentlemen enjoy the off season, the stack of snow-covered chairs and umbrella tables hint to spring's sidewalk charm on Commercial as "Spindler's," named for the 1922 shipwreck that spewed bottles of liquor along the P'town shore to the local's delight; try their $19.22 special commemorating that shipwreck year. The Waterford Inn, totally redone, still welcomes guests beyond restaurant and the courtyard.

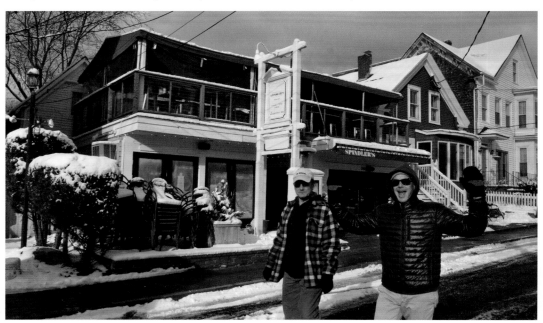

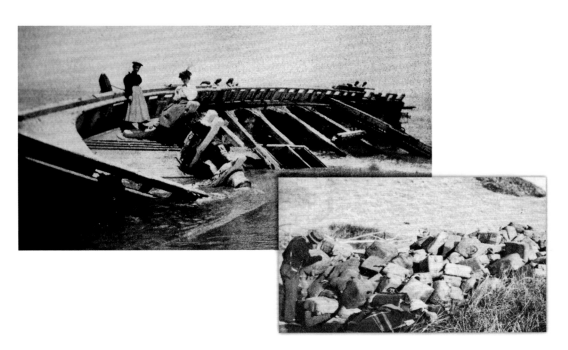

RUM RUNNERS: Visitors to the rum runner wreck of the British schooner *Annie L. Spindler*, December 1922, at Race point (My Grandfather's Provincetown blog). Although rum was shipped in from the Bahamas to avoid tariffs, this was a circumstance of 600 cases of Canadian whiskey from Nova Scotia during the days of U.S. Prohibition. Coming ashore exactly in front of the U.S. Coast Guard Station at Race Point, locals lined the beach hoping to get some whiskey "wash-a-shore," but with authorities' right there, they had no such luck. The wreck thus became the photo-opt of locals as these two dry maidens pose. Today, forget waiting at the shore, step up to the bar at the Boatslip Tea Dance and order one of Maria's Planter's Punch with an extra straw-filled shot of rum!

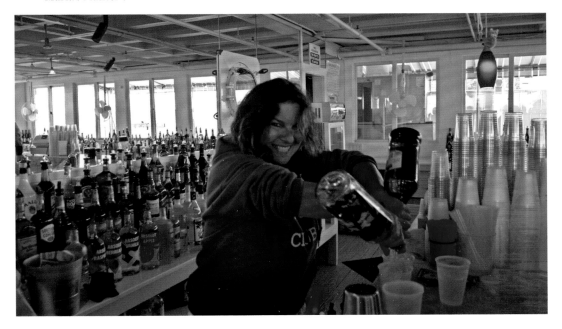

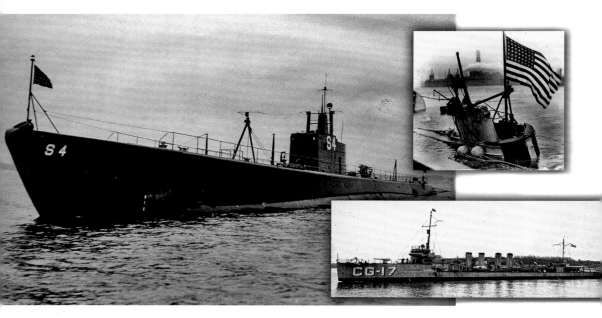

SUBMARINE SINKING: The submarine USS *S-4*, commissioned in 1919 and globally well-traveled until December 17, 1927, when the submarine surfaced in the P'town deep harbor and was involved in a ramming with the rum-running Coast Guard destroyer *Paulding*, which was also just entering the harbor; note the damage to the CG-17 above. The sub sank quickly out of sight and rescue attempts proved futile for the last six inhabitants (out of forty) remaining alive in diminishing oxygen; their last Morse code was "Is there any hope?" but all would perish. The lives of all the men are memorialized annually here at St. Mary of the Harbor Church; the event is chronicled in Joseph Williams' book *Seventeen Fathoms Deep*.

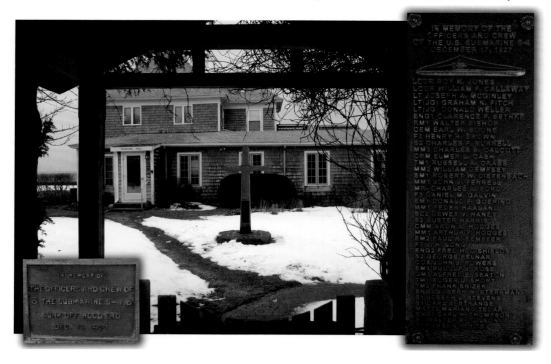

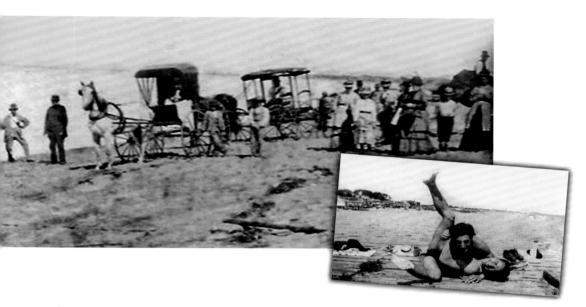

BEACH PARTY 1870 AND 1936: Seems difficult to imagine frolicking on the beach in the 1800s, but by the mid-twentieth century, for the free spirits with non-constricting clothes, P'town beaches were the place to play. Town lore has it that Tennessee Williams never missed a capering season while working on some of his best plays. Today, out beyond the dunes and the law, frolicking, sans fashionable attire, complete freedom sometimes occurs. Below: a P'town tradition of folks gather to watch the sun setting in the "west" and the colors it produces to oh-so-many "ahhhs" and cell phone photographers.

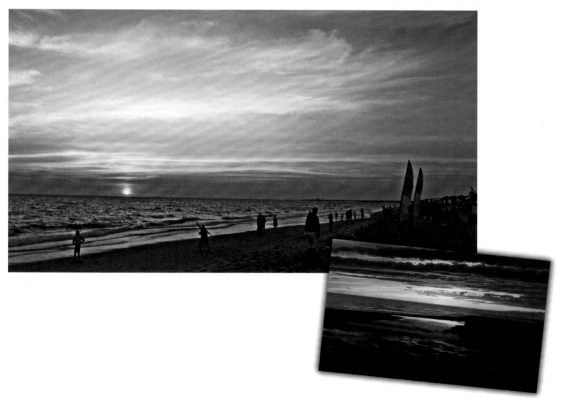

HOUSE OVER HOLLYHOCKS: Not that many years ago, Provincetown was known for its hollyhock abundance. Here, behind 401 Commercial Street, the "half-lot" was perfect for fishing boat storage and the random stocks of blooms. Eventually, the owners would build a boathouse that somehow morphed into this two-story view house with extended beach-deck but no hollyhocks. Not to worry, there still is a path to access the beach.

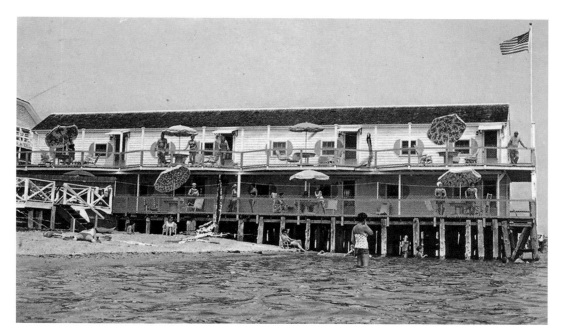

UMBRELLAS AND THE TIDES: An old postal card with the bright umbrellas perched on the decks of 421 Commercial Street and its tide watch before the "National Sea Shore" grass point planting program of the 1980s to preserve the beach. Dredging of sand from the harbor and depositing to increase beach width instigated this program, where homeowners (in this case by Susan Davis, assisted by Jan and Phyllis) received hundreds of "grass plugs" and planted them akin to "hair-plugs for men." That plus the breakwater just 835 feet beyond the MacMillian Pier, built between 1970 and 1972, guard against the storms like the "Portland Gale of 1898" that destroyed most of the small piers that dotted the P'town shore and where over twenty ships sank in harbor.

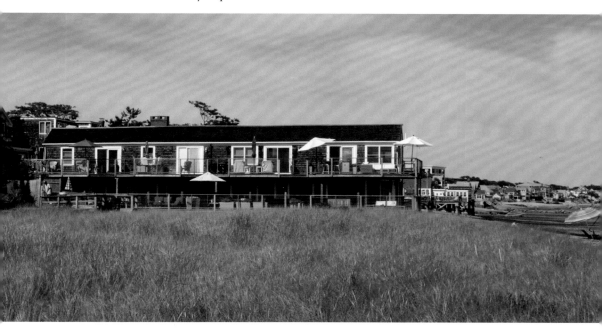

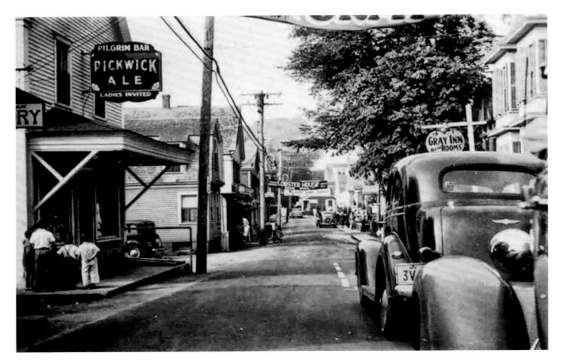

THE PILGRIM BAR AND EAST ENDS BOOKS: A 1938 snap from the collection of Eugene N. Fedorko and his "1930s in Provincetown" blog. Four boys are perhaps waiting for "Pa" outside the old Pilgrim Bar, which featured Pickwick Ale, the New England blonde ale popular since 1870. The bar now accommodates East End Books, P'town, with eclectic titles that are quite intoxicating.

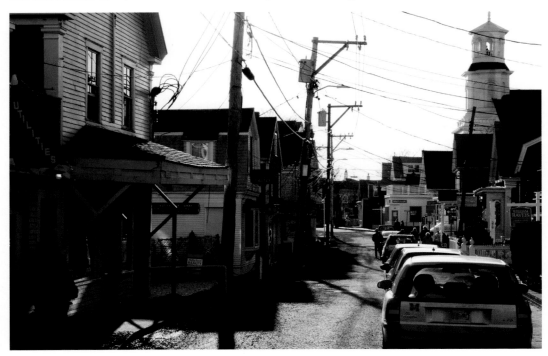

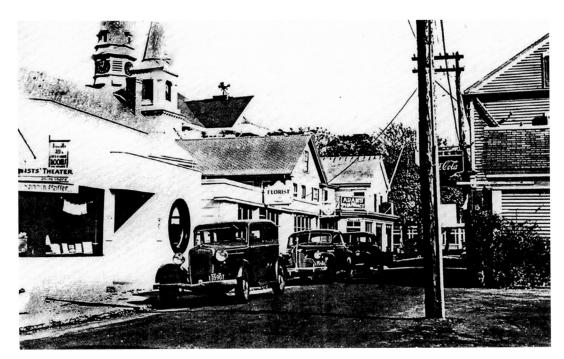

PROVINCETOWN BOOK PORTHOLE *c*. 1938: The longtime bookstore's round window is what gave the structure its nickname, "The Porthole Building." Rather tricky for product display, it was eliminated, save for the entry alcove (inset), but the building as the Provincetown Book store with a fine inventory laden main window remains the same—only the passing cars have change, especially the colorful P'town "love-cab." Note: the peak of the old steeple of the Pilgrims' church long replaced with Saki Restaurants.

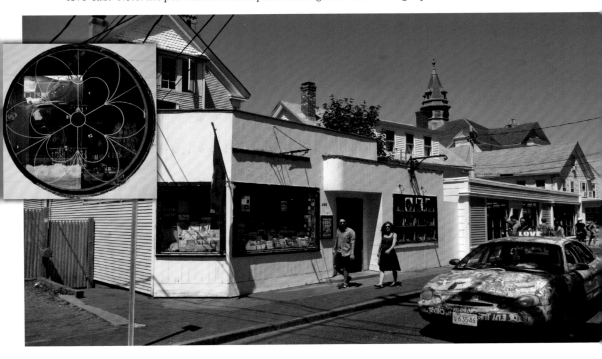

COMMERCIAL AND GOSNOLD: Horse and buggy days when these houses, set back from the road, allowed for picket-fenced yards. Today, the front yards are now Provincetown Books and Adam's Drugstore (note inset: the architectural columns removed to accommodate the retail, remain out the back of the house). The horse and buggy have been replaced by the SUV, and on the far left, instead of peering through the windows of Charles Burch's bakery at the fresh goods, it is tee-shirts proclaiming all kinds of pithy phrases, a few perhaps "half-baked."

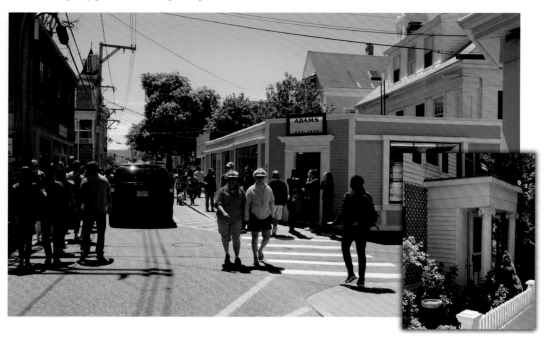

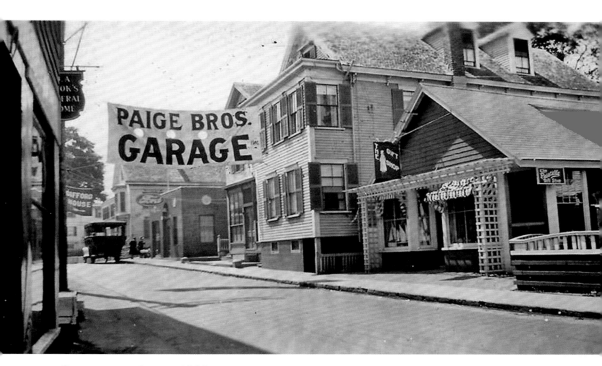

COMMERCIAL STREET 1930: A Paige Bros "accommodation bus", 25 cents around P'town, stops at Carver Street in front of the new Ford auto agency to let sightseers off. Below, with wire-scape abound, TimScapes and his P'town wear features most prominently on the twenty-first-century block; a stretch of Toys of Eros, The Beer Garden, Henry's Fashions, and, on the extreme right, the Fudge Factory (once The Priscilla Gift Shop). Across the street, the old Cook's funeral home signage has been repurposed with a coat of paint as Christina's Fine Jewery.

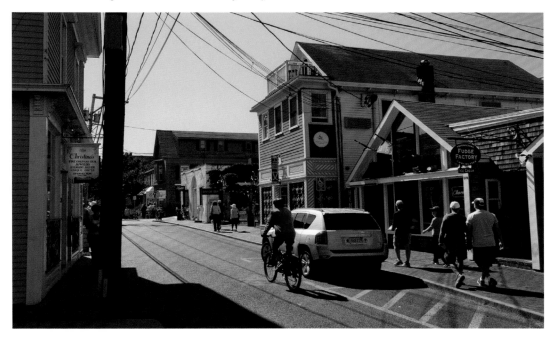

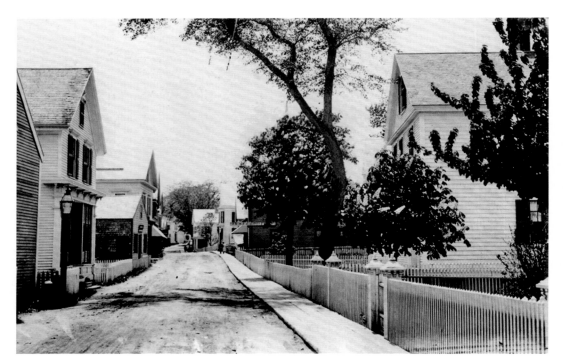

LOOKING WEST DOWN COMMERCIAL: The first three houses on the left here in 1890 were torn down to make way for the Post Office as a WPA project in 1933, and across the street the three-story house came down to accommodate a more modern theatre, the Brew House (the beer & food bar), and shops for P'town's fashionable "T"-wear. Note the "Y" tree in the front yard and on the next page twenty-five years later.

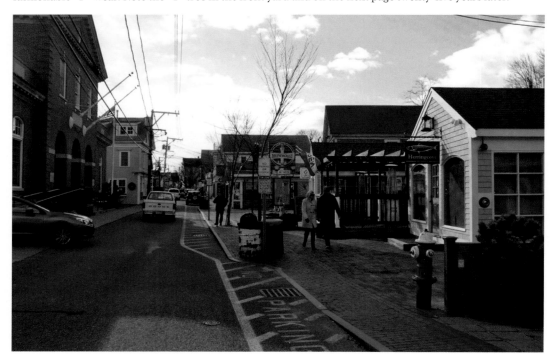

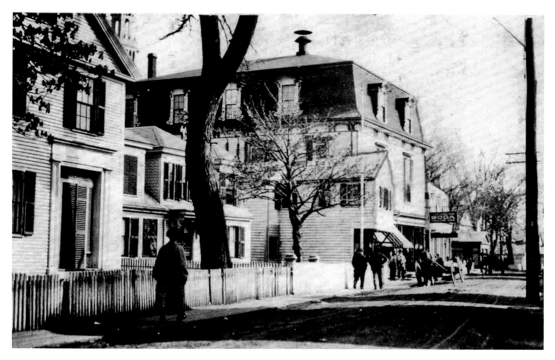

LOOKING EAST DOWN COMMERCIAL: Business as usual on Commercial Street in 1915 with a few houses still not being repurposed to retail. The Masonic Temple seen at full height would be lowered a story shorter by 1972. Observations of the page before in 1890 include the skinny "Y" tree's growth, a bit plumper, but still not a good climbing tree; so goes the tree when the house came down for modern retail developments.

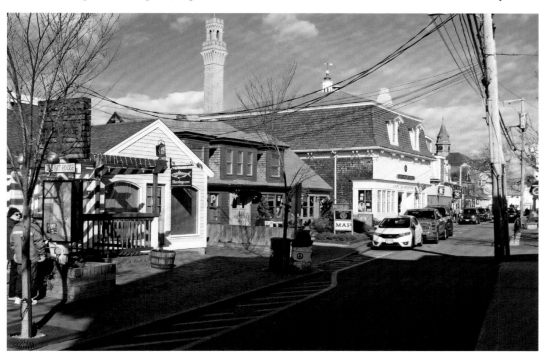

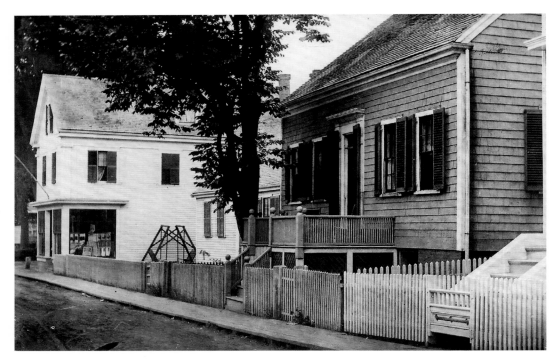

FULL KIT'S SHADY PAST: Bessie Freeman's home at the turn of the century shaded by a well-placed tree. Her neighbor's house would become Spiritus Pizza and Bessie's home a gallery space. But it would have been much to Bessie's surprise to discover the paraphernalia found in her basement—the "leather delights" offered by the now shop space "Full Kit Gear."

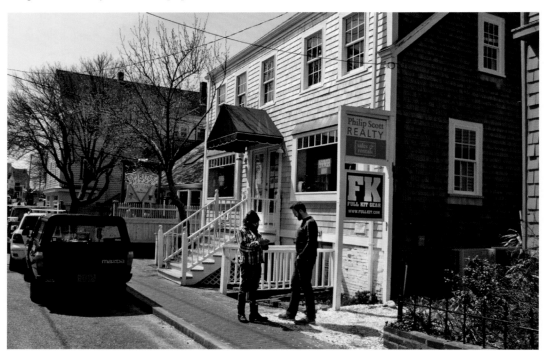

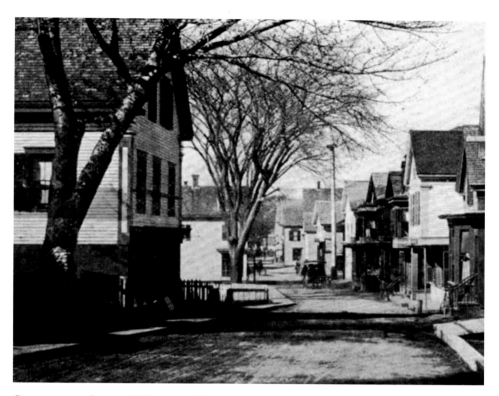

COMMERCIAL STREET'S WEBSTER HOUSE: Looking east down Commercial Street in the late 1800s to the left is the Webster House, built in 1850 with shop space at street level. Directly across, note the bay window, which is better seen in the inset as Bayside Betsy's. The nineteenth-century horse-drawn buggy would be passed on the left by the twenty-first-century's sports car.

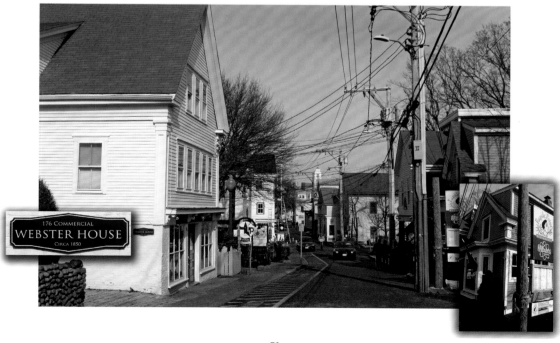

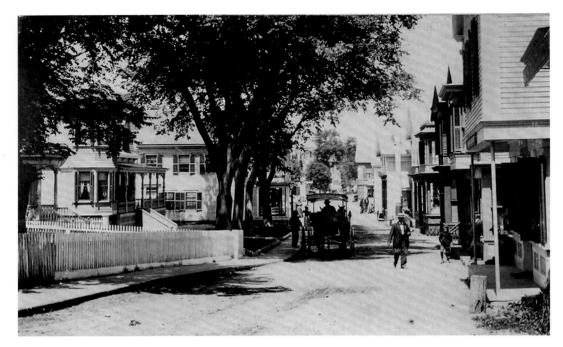

TREES & TAXI TALES: An article in the *Provincetown Advocate*, July 5, 1871, touted Mr. Samuel Knowles, coaches (taxis), pictured above, "having been rejuvenated with new axles, wide tires, freshly painted and varnished, and a greatly improved appearance to keep up with the times". These gentlemen stopped on the wooden sidewalk engrossed in shaded conversation with Mr. Knowles. Some sixty-seven years later, those trees on the left would be uprooted as so many were in town by the hurricane of 1938. Now it is brick sidewalks and sunshine, so don't forget a baseball cap.

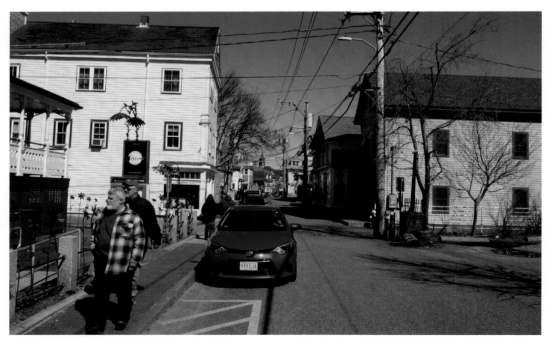

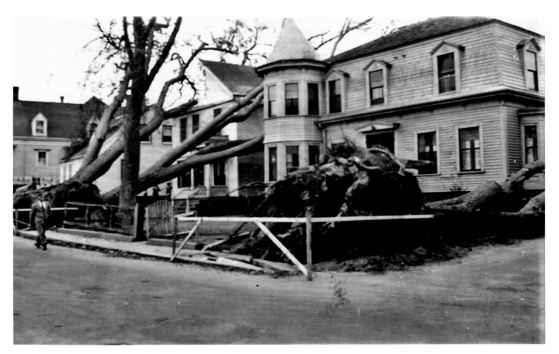

TREES & TAXI TALES 2: The hurricane of 1938 uprooted trees that had been around since Commercial Street had been laid out in 1835 and played havoc on this nineteenth-century home's sea-view front porch. Traditionally a, large family home served culinary feasts to its seafaring men. Now converted to commercial use as Enzo Guest House and "Local 186", it serves some of the best burgers in town from their enlarged front porch surrounded by wrought-iron flowers to withstand any storms.

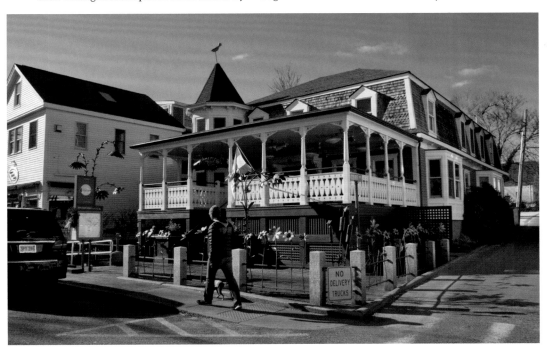

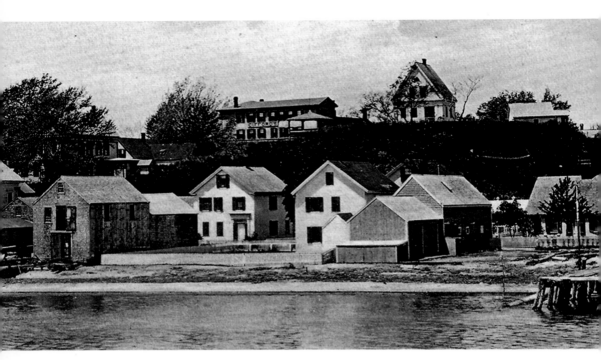

THE GIFFORD HOUSE: Early to mid-1800s view from the harbor of the Gifford House Inn and the Gifford family home quite prominent in the middle at hilltop. Note: the Gifford House's front entrance, as seen here, impressively faces the harbor. The buildings on the harbor side of Commercial have been replaced with the post office and Seaman's Bank, with a couple of houses still recognizable from the past as favorite shops for cards and gifts (blocked by the large Colonial ice warehouse below).

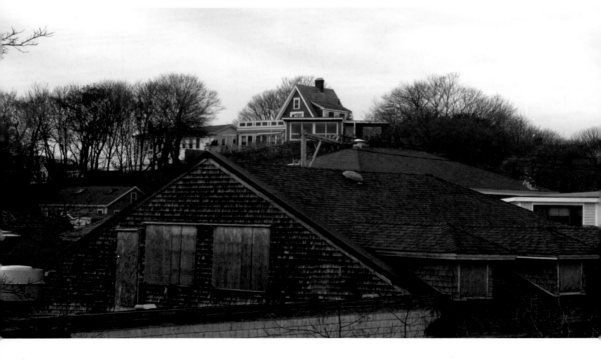

HOW DO I GET TO THE GIFFORD HOUSE?: Here on Commercial Street at Carver, c. 1886, is a sign that directs visitors up the incline to the big yellow inn, The Gifford House. (In the 1930s, a directional banner took its place.) The two houses from the corner would be replaced—gas light, "leaning-lad," and all—by a new, modern structure, the 1920 Ford Automobile Agency, which remains today as the Kiehl's Skin Products, Toys of Eros, and the popular Beer Garden. The third house is now the distinctive P'town design T-shirts and other "P" accessories, TimScape. The upper-right corner is a peek of the roof top of the Masonic lodge. The whole structure would be dropped one floor by 1972 to a lower profile just barely visible below.

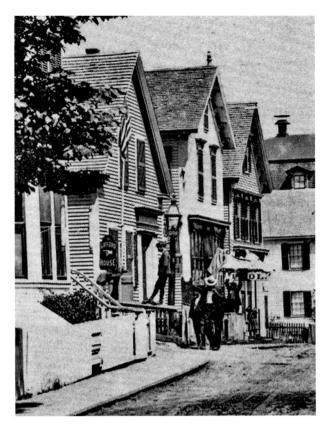

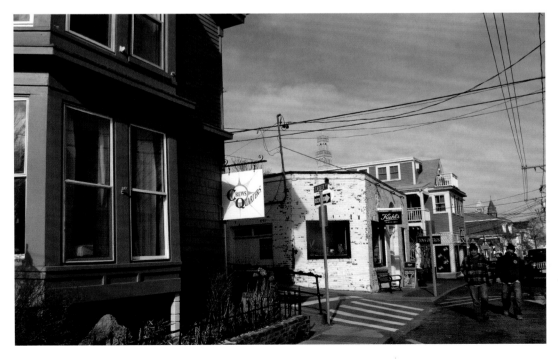

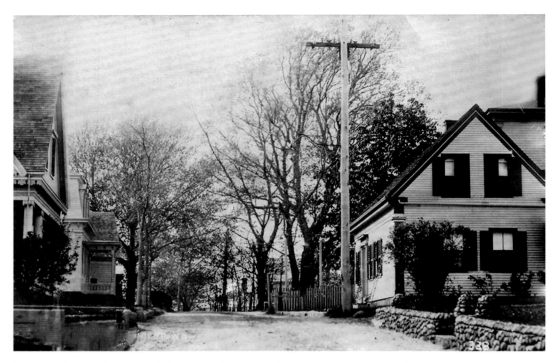

CARVER STREET: At the top of the Carver Street steep hill, before you get to the Gifford House, are fine examples of late nineteenth-century homes. Most have been redone and converted to guest houses to serve the twenty-first century, with some architectural details remaining for urban detective work, such as columns on the extreme left. Today, on any evening, one finds a late-night hub of activity worth the uphill climb.

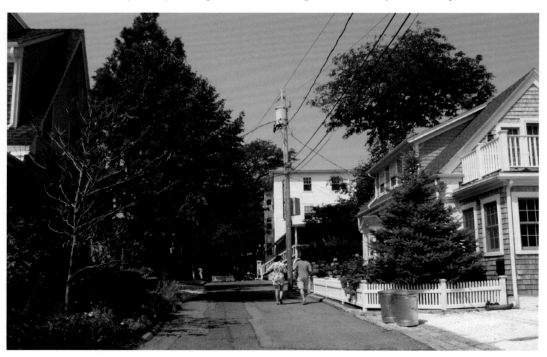

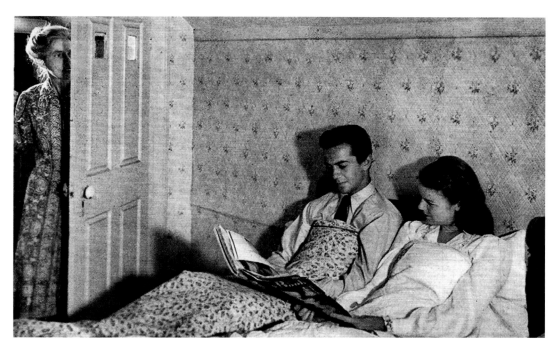

P'TOWN BUNDLING: Staged by photographer Robert F. Sisson, this pose of famed real estate and newspaper woman, Mrs. Harriet Adams, in her Provincetown home in the 1930s shows her peeking in on a courting couple in bed, illustrating a winter tradition in New England since the 1800s called "bundling." With the door ajar and peek-a-boo door openings, the couple would be tucked under the covers but separated by a "centerboard" with no knot holes. Today's courting in Provincetown is a bit more progressive, with the daily summer tradition of the "Afternoon Tea Dance" at the Boat Slip (*Where's Waldo*). A meet and greet beyond the grasp of those of ol' P'towners. And let's not mention the "courting" that goes on below the deck, a.k.a. Dick Dock.

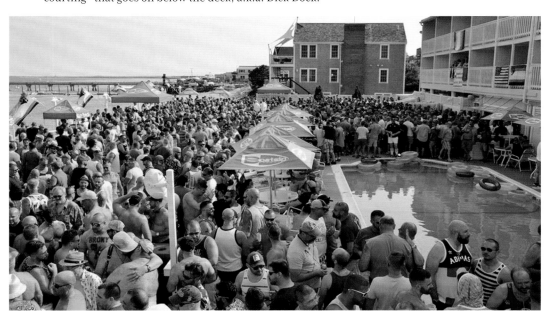

CUFFY'S PAST: Checking out the changes (above): in the 1930s as two stores and in 1948 as the Town and Country Restaurant. By 1948, the side stairs up to the apartments had been enclosed with its entry door incorporated between the store fronts. Today, it's Cuffys, a favorite stop for tourists seeking Cape Cod souvenir "sweats and tees" or just a rest in one of their porch rockers shaded from the noon day sun.

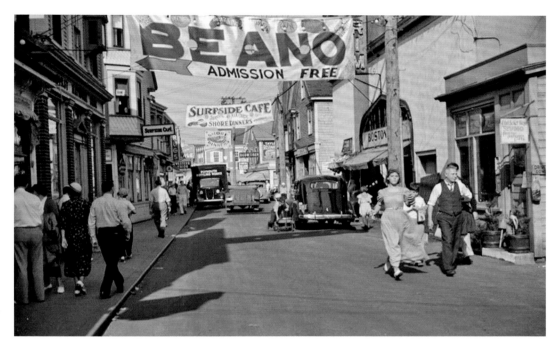

BANNER BONANZA: It's Commercial Street, late 1930s, when traffic ran both ways. An overhead banner touting Beano (a popular 1930s version of Bingo), you just followed the arrow to a seat inside the old silent movie house. Today, there is nothing silent about the house—now the colorful Shop Therapy. Biking down the same stretch under another collection of banners is Provincetown's own Lip-Schtick, a one-woman parade hyping her evening show. Her swift costume changes are aided by her organized closet full of her custom hats and ensemble with her own fabric designs. Check out her "Gams."

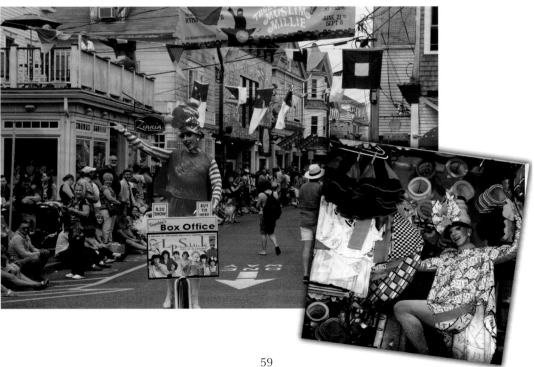

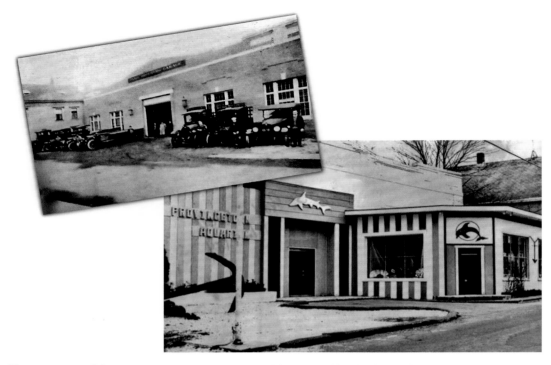

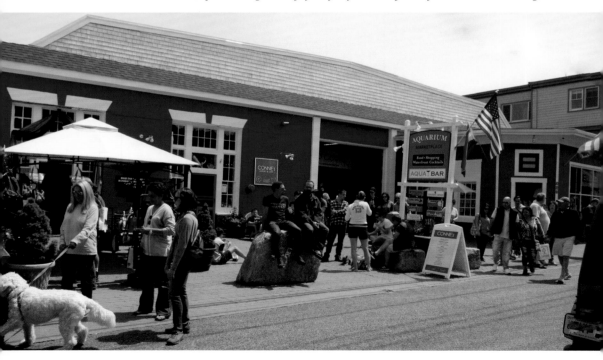

TANKS FOR THE MEMORIES: Originally the Paige Bros' Garage in 1920, the deco architecture gave way to the 1960s Provincetown Aquarium. Hence it is still called the Aquarium and the pub out back, The Aqua Bar. Now sit out front on a rock, enjoying a selection from the now food court or a pastry from Connie's and contemplate: "Where has that anchor gone, Lopes Square?" Note the recent roof line change for a rather eclectic architectural statement. (*Aquarium image courtesy of Lisa Jean from the "My Grandfather's Provincetown" blog*).

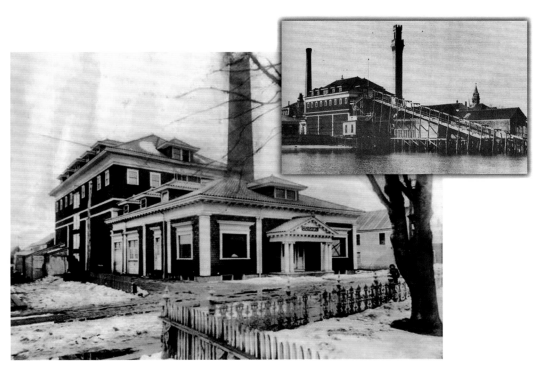

THE COLONIAL ICE HOUSE: Here in the middle of town, in a 1900 snow-laden image, was one of the several ice houses for processing the "Catch of the Day," Cod. The power plant was up front with the large freezer in the back. Conveyor belts (inset) would transport the fresh fish from the fishing boats docking out back. At one time, there were seven such ice houses: the remnants being the "Ice House" condos on the east-end and the Colonial House above. No ice today—as retail, they just sell cool beach clothes.

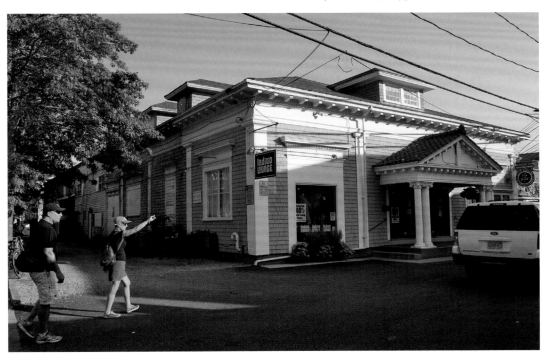

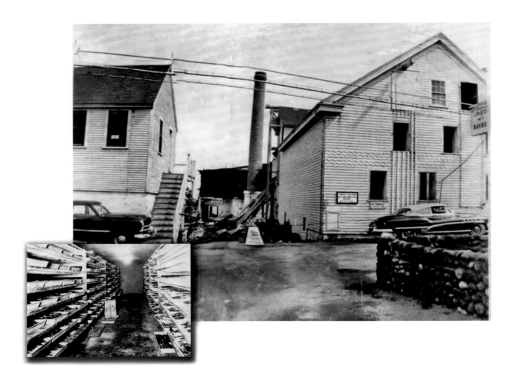

COLD STORAGE AT THE END OF JOHNSON STREET: The Johnson Street Cold Storage Company was one of the seven major fresh fish freezing facilities along the shore since around 1895. Shelved trays (inset) would hold the catches of the day, but by 1952, its usefulness waned; it became more advantageous to P'town as a parking lot, here at the end of Johnson Street, keeping the cars cold off season. Note the stone wall in lower right, surviving the change, quite popular in yard décor in Provincetown and plentiful as it had been used as ballast for cargo ships from foreign shores and traded weight for cod.

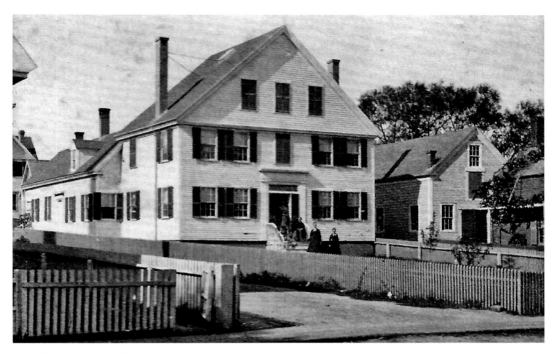

JOHNSON AND COMMERCIAL: In the mid-1800s, when Johnson was a narrow driveway-like lane, the imposing house with posing folks on the corner situated between Johnson and "Little Johnson" (now Arch Street) had a grand front lawn corralled by the traditional picket fence. With commercialization, the lawn was sure to go and for years little shops fronted the prime real estate. Below: those little shops have been raised to make room for better little shops. As for the big white house: "Condos"!

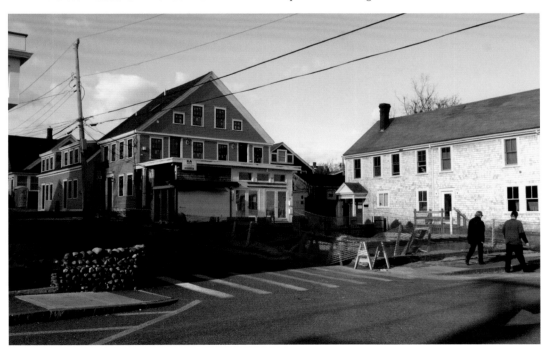

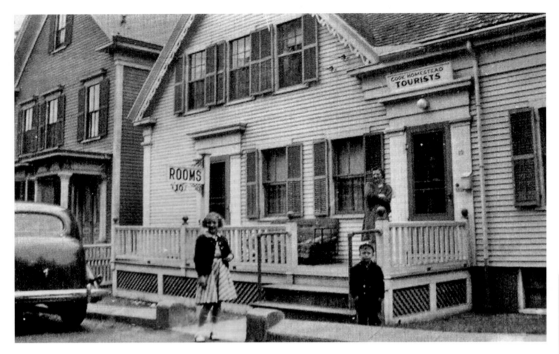

ROOMS FOR RENT ON JOHNSON STREET: The Cook Homestead at No. 10 Johnson Street here in 1940 as Adelaide Kenney and family are posing in front of the guest house they ran—the large icehouse could be found at the end of the street, and is now a mid-town-parking lot. Today, much of the home's gingerbread is gone and Johnson Street has followed the trend and is mainly "Guest-House-Row." (*Courtesy of "My Grandfather's Provincetown" blog, Skip and Arpina Stanton*)

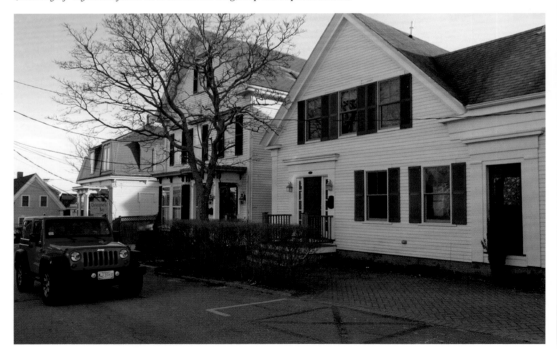

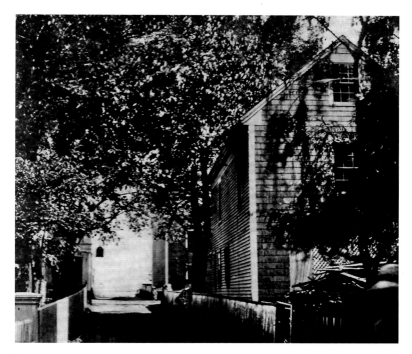

LITTLE JOHNSON: In the mid-1800s, Arch Street, a.k.a. "Little Johnson," as it ran behind and parallel to "Big Johnson" (no pun intended) between Bradford and Commercial. Usually first noticed by motorists as they motor in on Conwell and stop at Bradford for a right or left turn decision. But Arch is really best just for foot traffic, especially on a snowy afternoon (as seen below).

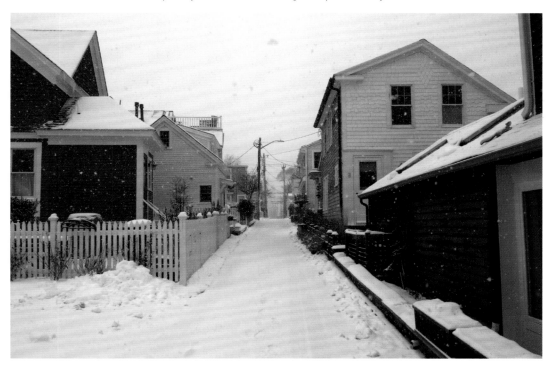

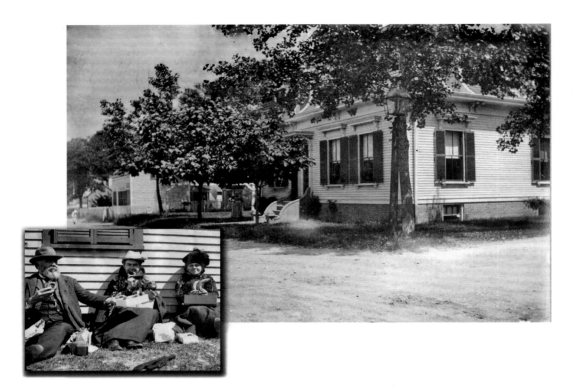

BAGELS AND BANANAS: The Maria Rich home above, *c.* 1900, at Bradford and Johnson, with Maria in inset at center with her uncle, Solomon, enjoying bagels and bananas (*c.* 1920). Today, on a snowy afternoon, the detailing of the "fresh fall" accents the Mansour roof and beauty of a home hidden most of the year by its high fence and foliage. Our twenty-first-century pedestrian may be crossing Bradford for Farland's Market—for what else: bagels and bananas.

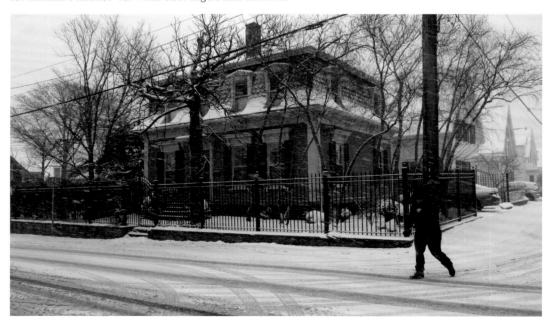

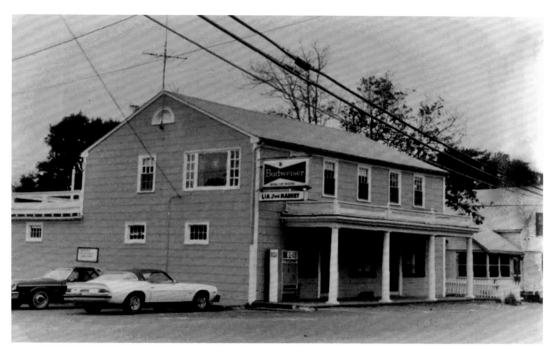

FAR OUT, ITS FARLANDS: At Bradford and Conwell, the little market has been serving the East End for years. Above, as Nelson's Grocery (*c.* 1977) and below today as Farland's, transformed in snowy effect, just grab an incredible sandwich, catch up on what's happening in the neighborhood, and don't forget what provisions you might need on your way home. Months from now, they also have a summer season Herring Cove pop-up location right on the beach.

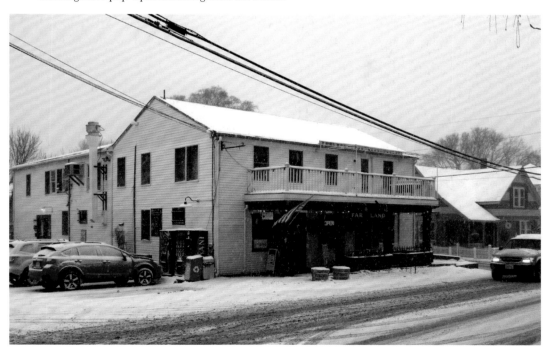

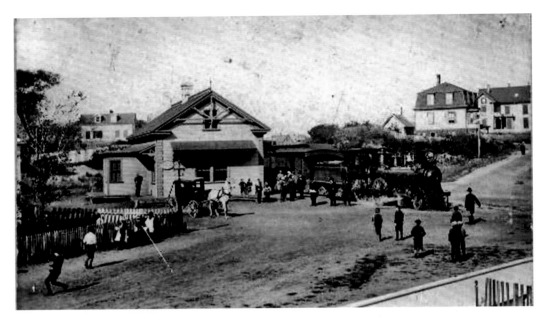

TRAIN TIME: July 1873, without much fanfare, Provincetown welcomed the "Old Colony Railroad" and the trains it would bring for the next twenty years, including the above Baldwin-built 1881 train. The route then taken over in 1893 by the New York, New Haven, and Hartford line (1893–1959) would continue beyond the station, rumbling past the "New York" store at Commercial and Standish, to the end of the pier. July 1938, without much fanfare, the station would close to passenger service (freight train usage would last until 1960). Bus parking and any passenger service up cape to Provincetown would utilize the empty station along with the friendly snack bar, as seen below in 1948, until 1950 when the corner would take on a complete unromantic view and train travel replaced ironically by automobile sales of Duarte Motors featuring Chevrolet and Oldsmobiles.

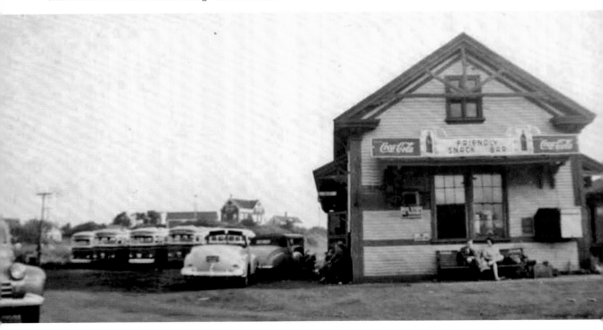

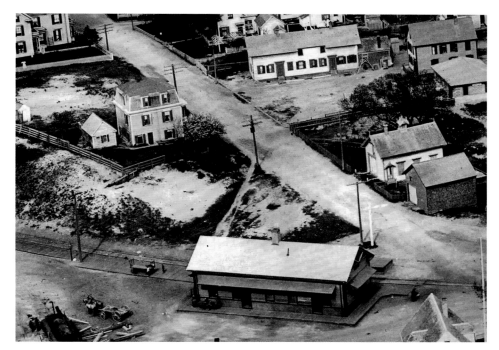

TRAIN TO TEE SHIRTS: Originally a boon to Provincetown growth, among other benefits, the building of the train station and rail lines coincided with the Bradford Street eastern development. But eventually, the pride of P'town train transport would be outdated and that too of the Duarte Motors days; the corner is now no longer connected with transportation, except as parking facilities, and the space was used for a while as the "Duarte Mall," which featured a staple of P'town: the tee shirt. The junction's future is up for constant debate: to CVS or not to CVS! I guess with the train tracks and "right of ways" removed, bringing the trains back is out of the question.

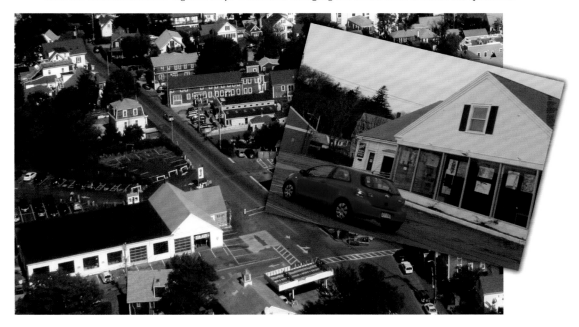

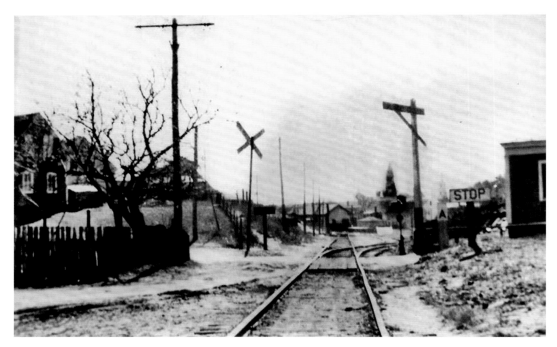

TRAIN TRACKS CROSSING CONWELL: Now known as Harry Kemp Way, prior to the 1960s, it was train tracks right-a-way leading into Provincetown Station, as seen above off in the distance. Harry Kemp was known as the "Poet of the Dunes," for he truly was as one of the more bohemian citizens of P'town that lived and created poetry among the shifting sands. The railroad access now serving autos is rather non-poetic, but at least honors Harry's memory. His image, thanks to the Provincetown History Project, is from the1950s; he died in 1960. "With casual riches which he gave away, Bringing me the priceless gifts of Day"—Harry Kemp.

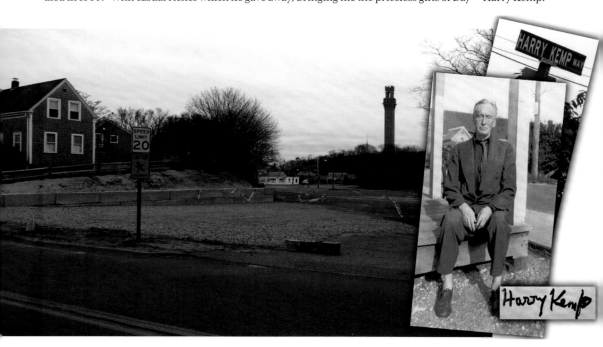

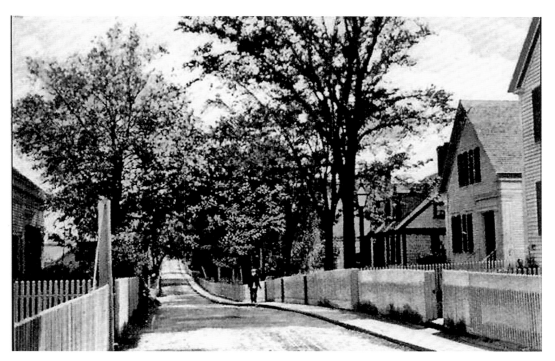

THE UNDERGROUND RAILROAD: This row of houses on the West End is post card perfect, with most built around 1807; a couple even floated over from Long Point in the mid-1850s—even more notable than it seems. At the time of this image, a gentleman is strolling by the home that was part of the "Underground Railroad," hiding black runaways escaping slavery in the South. The gabled house, No. 54 Commercial, in inset below, is so honored by that freedom history!

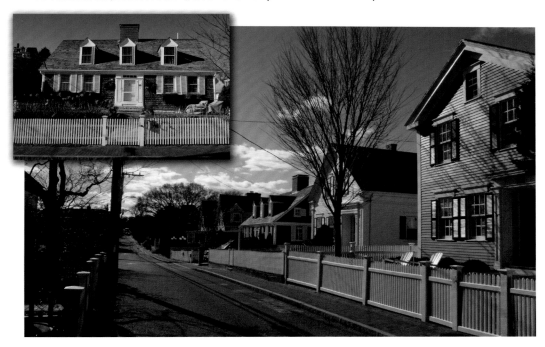

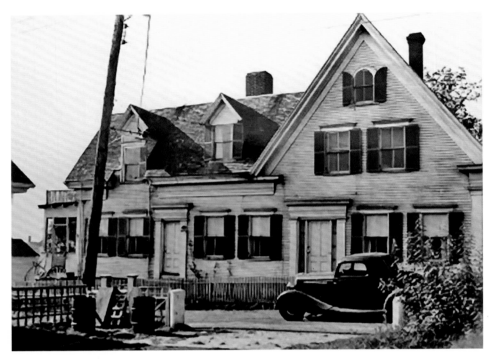

NICKERSON HOUSE: Looking a bit weathered in this 1930s image and then again today, saved by more than just a coat of paint: the diligence of true fixer-upper devotees. The Jonathan Nickerson house was built in 1853 on a path leading from the beach, crossing the newly laid out Commercial Street, and dubbed by where it led, "the new Nickerson's place."

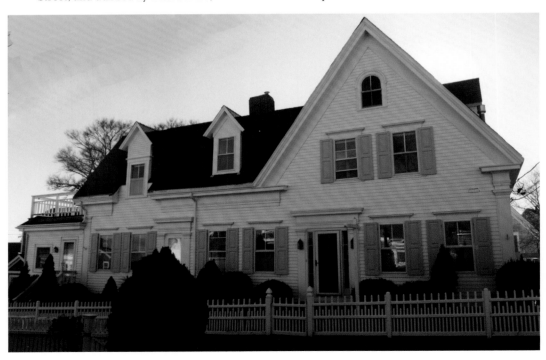

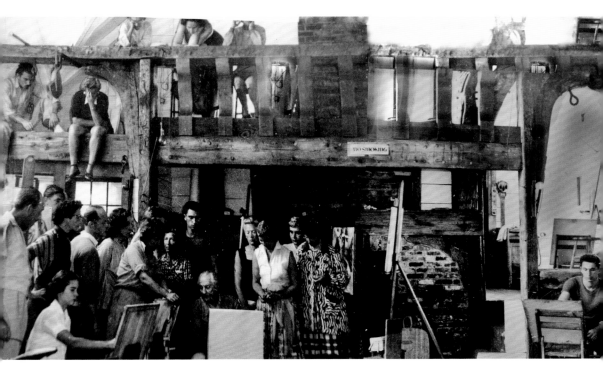

HANS HOFFMAN'S STUDIO: From the archives of the current homeowner: a panorama of students studying with Hans Hoffman in his West End studio on Nickerson at Commercial Street, *c.* 1945. A large east-facing window allowed for the perfect lighting for his classes, as it does for today's homeowner in his great room.

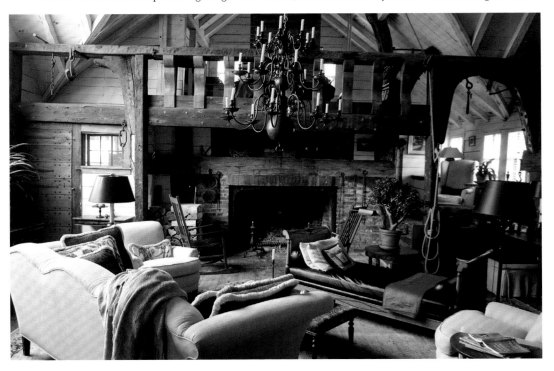

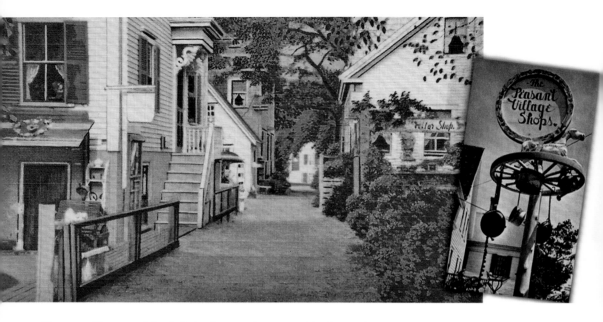

PEASANT VILLAGE: Mostly little shops and cottages, it's often referred to as "Peter Hunt Village" after the folk-painted furniture of Peter Hunt, whose gallery headed the Court on Commercial Street. When arriving in P'town on the East End in the 1920s—with F. Scott and Zelda Fitzgerald—Mr. Hunt, with a bit of a flourish and while holding the leashes of his Afghan hounds, announced that he had found his home, naming his enclave "Peasant Village" (1930–1960). Now Kiley Court, it's a destination for both locals and visitors to explore its numerous galleries and the famed Ciro & Sal's Italian restaurant and bar.

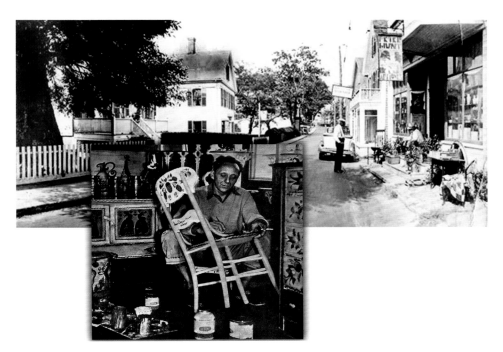

PETER HUNT VILLAGE: Peter Hunt in a 1952 image from the My Grandfather's Provincetown blog, working on one of his recreations. An expert at being colorful himself, his colorful repurposing of furniture pieces are treasures to be found in the homes of P'town today and quite collectible. His Peter Hunt Gallery above on the right is now the Kiley Court Gallery.

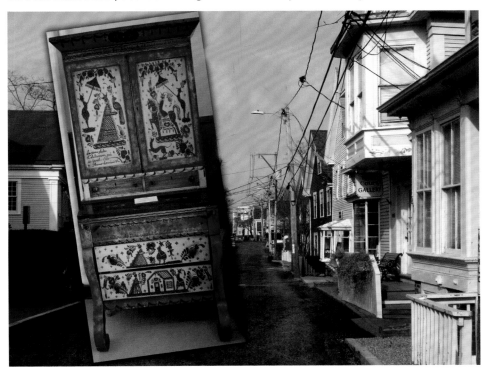

EAST END HOUSES: Just east of what is now Kiley Court was this home typical of the late nineteenth-century build-up of the residential East End. Of course, many of the art schools (with classes held on the beach) and artist lofts were to be found here and the "gallery growth" and the fine restaurants would follow. Today, some of the homes still remain in the mix with the landscape advent of "privacy hedges."

ILONA ROYCE SMITHKIN: The premier P'town treasure and named 2016's Woman of the Year is known to all as Ilona; here at the left with artist Henry Hensche in her Gallery about 1965. An artist herself, born in 1920, known for her "red" hair and the long lashes, she created from clippings of her own hair; she is quite the inspiration and role model for today's Provincetown artists and the art scene itself! (*Photo provided by Margo Scheider and the Ilona Royce Smithkin Gallery*) The artist Henry Hensche, born at the end of the nineteenth century, arrived at Ellis Island when he was eleven years old, but by the summer of 1919, he was in Provincetown and maintained a home in the artist colony until his death in 1992. A student of the Charles Hawthorne, Hensche had continued to be integral in the Cape School of Art. Below: author/photo-artist Frank Muzzy clowns a pose with Ilona as "two redheads out on the town" at an art opening at the Ray Wiggs Gallery.

STEEPLE CHASE: Photographer John Smith (1859–1945) was given special permission in 1925 to climb up inside the picturesque Christopher Wren steeple of the Unitarian Church on Commercial to photograph up Winslow Street past the high school and include his home, still visible at the top of the hill. Spring trees hide the rebuilt high school after a fire in 1930, but this author/photographer was given special permission to retrace Mr. Smith's efforts. Although aging gracefully, it must be noted, the steeple climb within and as viewed from a distance reveals a 15 percent (but still safe) lean.

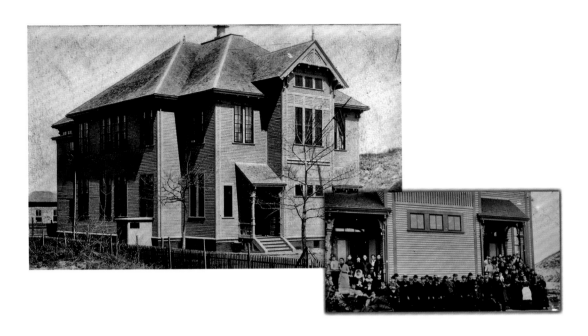

THE HIGH SCHOOL UP ON WINSLOW: The first permanent high school was established in 1851, and by 1880, the above structure with one of the first graduating class in inset was built, housing "High, Middle, and Lower" schools, serving well until a fire in 1930. Below: sifting through the ashes, plans to rebuild using brick and mortar (inset below) were a must. The final graduating class of the "High" school (closed June 7, 2013) consisted of eight students.

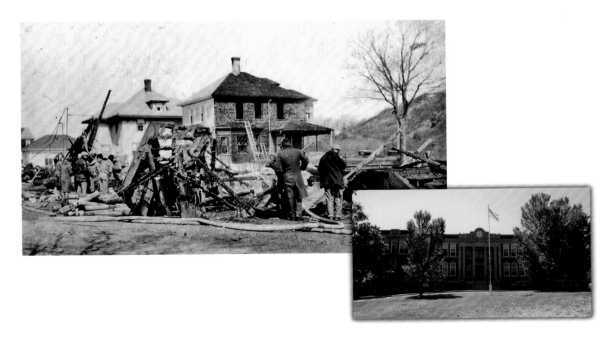

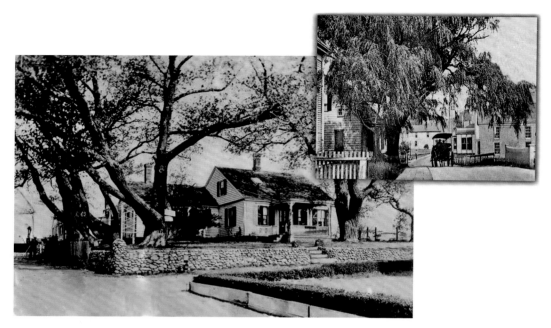

THE WILLOWS: The house named the "Willows" on the corner of Tremont and West Vine, seen here in 1910, still retains its charm today, even without the majestic trees as it fronts the "Willows" condo enclave. Willows were the import tree, a "wash-a-shore" of the horticulture world, back in 1827 when a whaling captain brought three saplings from Napoleon Bonaparte's grave at St. Helena to propagate in P'town. Inset above from 1906 is of one of the saplings making good back on the East End but subsequently removed.

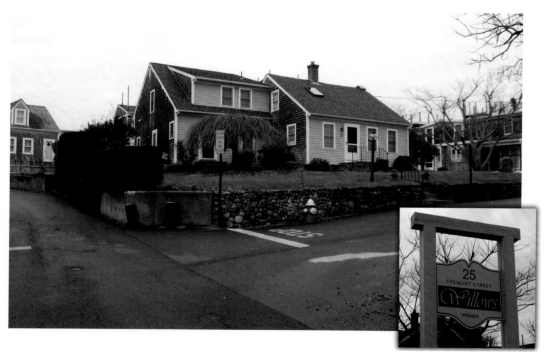

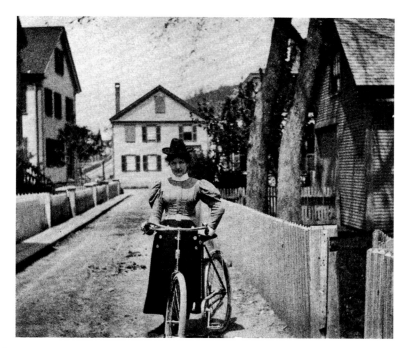

LADY CYCLIST ON GOSNOLD STREET: For more than 150 years, biking has been the best way to get around P'town, although a bit tricky with today's tourist traffic. This cyclist in 1902 is on the quiet street, named for Bartholomew Gosnold, an English explorer who in 1602 dubbed the "spit" of land Cape Cod after his great catch of codfish. By 1727, "Cape Cod" became the name for the entire landmass, with incorporation, the town designation choices were either "Herrington" or "Province Town"—"Welcome to Provincetown!"

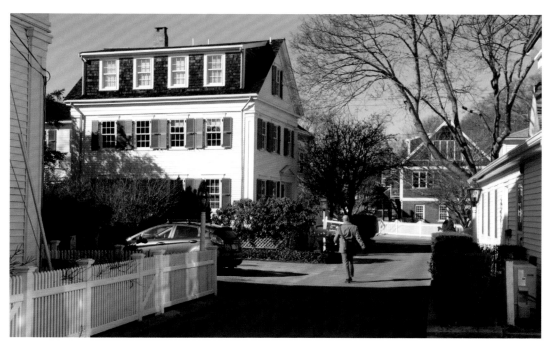

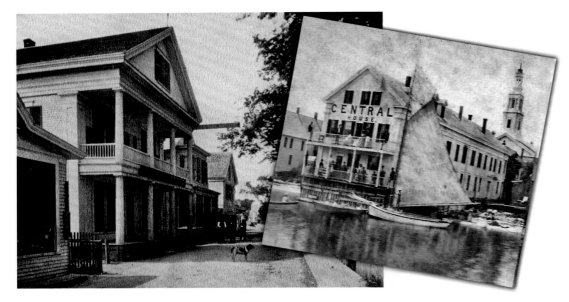

OCEAN HALL TO CROWN AND ANCHOR: Dating back to 1836 as a public meeting place known as the Ocean Hall, the Crown and Anchor wore several monikers. First converted as a hotel in 1868 by the Reed family and named the Central House, the only inn on the shore—seen above, "street-side," and "beach side," both *circa* 1900. (*The Perry Photo Co.*) In 1903, adding more rooms and a roof line change, it became the popular stopping spot the New Central House, beginning a century of name changes: the Towne House and then the Sea Horse Inn, and by 1962, catering to the auto-tourists, it became the Crown and Anchor Motor Inn. Today, surviving some architectural changes, a devastated fire, and those name variations (the Sea Horse Inn?), the Crown and Anchor and its multi-night venues remains a popular public meeting place—especially as below during Carnival.

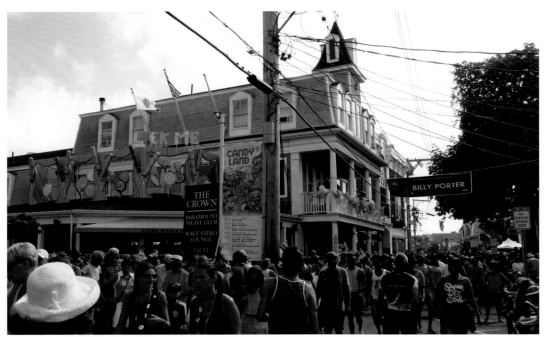

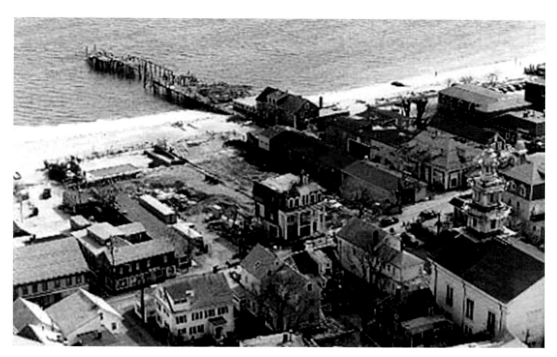

AFTER THE FIRE, THE OUTCOME: Joyce Johnson's image (above from town archives) soon after the fire allows the contrast and shows how much went up in flames; that night's quote: "We might lose the whole town." The Crown and Anchor, saving the integrity of the facade and the swimming pool, rebuilt better than ever as well did the Provincetown Theatre/"Whaler's Wharf." Note: Interestingly, the Crown and Anchor now hosts the annual "Fireman's Ball."

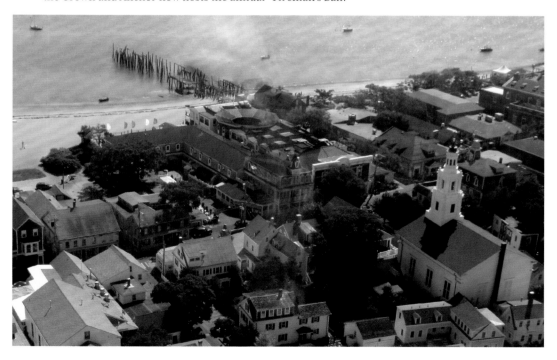

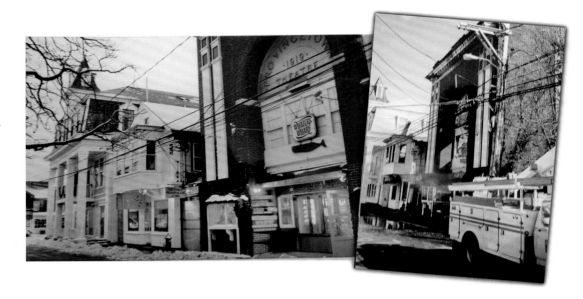

WHALERS WHARF JUST BEFORE THE FIRE: On that night, February 10, 1998, also up in flames with the Crown and Anchor Inn and the "Handcrafter" shop next door was the old Provincetown Theatre, built in 1919; it had been repurposed as the shops of Whaler's Wharf. (*Inset image: the Lee Bartel collection, P'town Library*) Below: another image from "another" February 10, the new Whaler's Wharf is back and full of shops, wonderful art galleries, and restaurants, as well as a new Provincetown Theatre, now home to the Provincetown Film Society Institute. Right next door, it's the new Crown and Anchor.

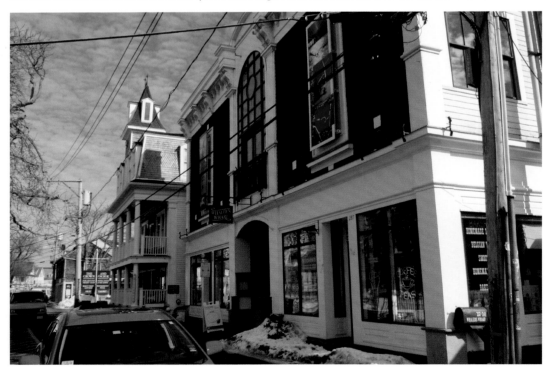

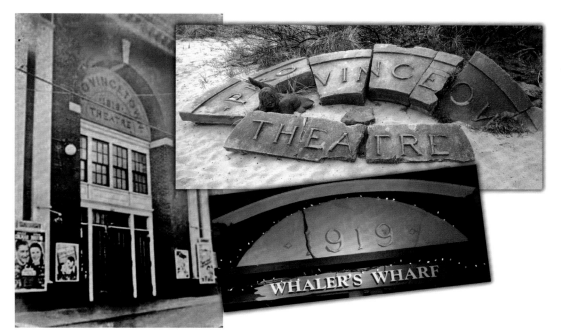

SIGNAGE HISTORY: A 99-year sign history of the Provincetown Theatre as fragments of the stone signage that was once above the entrance remain out back of the "Wharf" (often a posing spot for cellphone photos) and the original theatre's dedication date, "1919," suspended above as you first enter the complex. Below: on a cold day in 2018, some of the "P town Film-Fest folks," do their posing at the lighting of the new marque ready to makes its distinctive electronic announcements of show-times at the Provincetown Film Society Institute Festival Cinema's "Waters Edge."

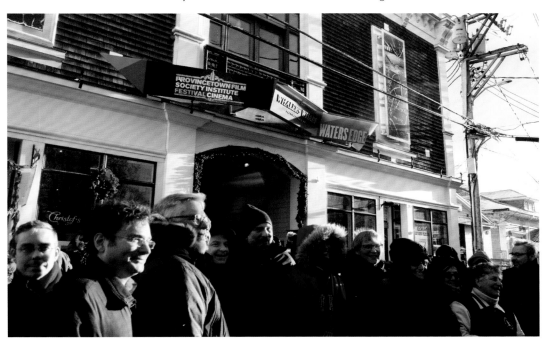

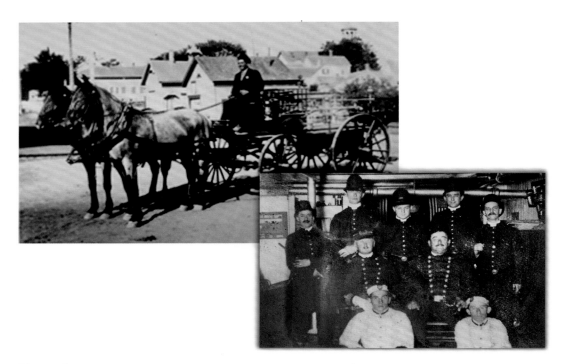

P'TOWN PUMPER: The first horse-drawn firetruck, *c.* 1900, was the pride of the volunteer firefighters of Provincetown, seen above in 1906. They were known as saviors of the town, as sea breezes often fanned the flames of destructive lighting strikes, burning homes, churches, businesses, and even the original hilltop Town Hall. Today, with numerous upgrades in the latest in firefighting equipment and fine firefighters to go along with it, the old pumpers of P'town are brought out for the numerous parades and for a display along with a few firemen at the Fireman's Ball at the Crown and Anchor—one of the popular summer "Bear Week" events.

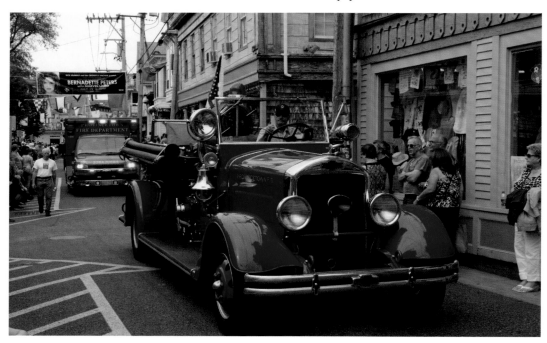

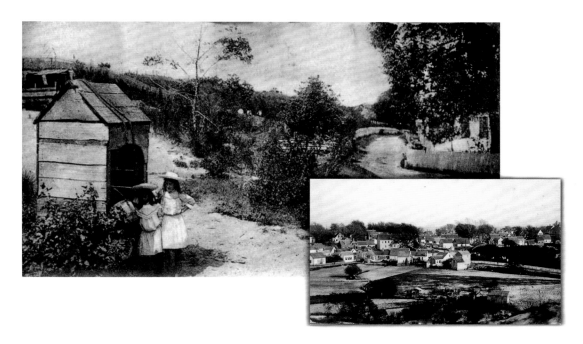

BUCKET BRIGADE ON COURT STREET: In 1900, two little girls collect a bucket of water to tote home from a community well here on Court Street, the Winthrop Street cemetery just beyond on the left side of the road (note the graves). On the right side, just around the bend (seen in inset) was Pumpkin Hollow, currently buried under mounds of sand and construction storage. As for the well, well, everyone today has indoor plumbing.

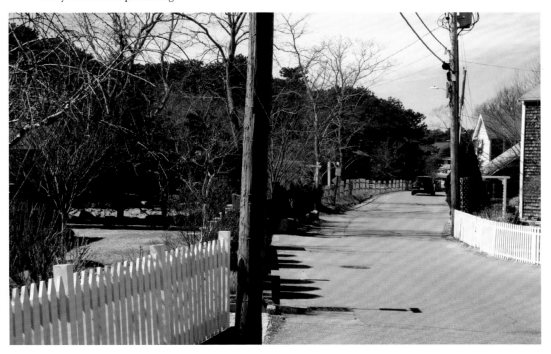

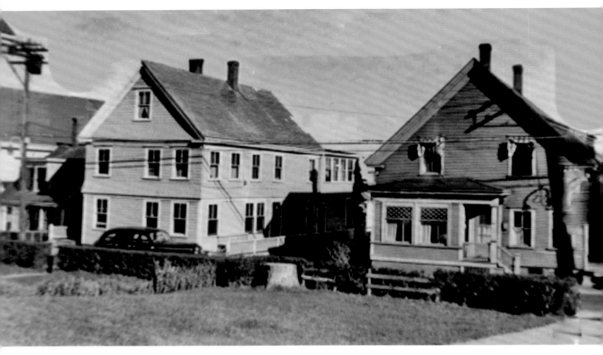

VIEW FROM THE CHURCH'S EAST SIDE STEPS: From the top step of the Methodist Episcopal Center Street Church in 1946 and again today. Built in 1860, the church has gone through several changes in its view and history, from church to town library, including serving as a museum (1956–1971) for Walter P. Chrysler's large art collection after he sold his NYC Chrysler Building.

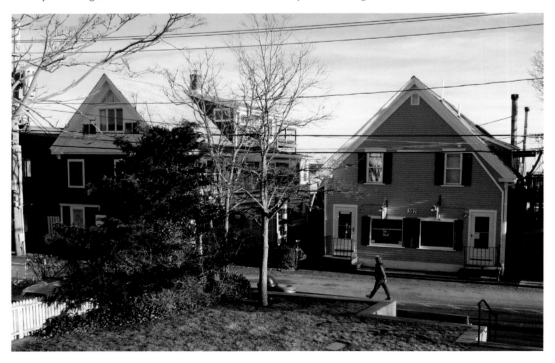

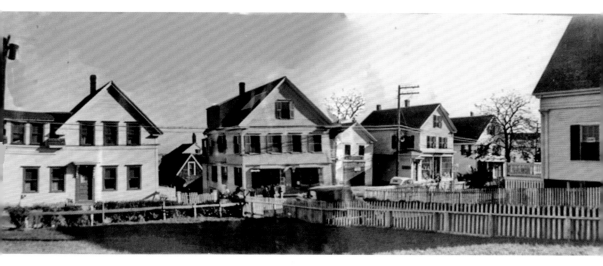

VIEW FROM A CHURCH'S WEST SIDE STEPS: Just across from the steps of the Methodist Center Street church in 1946 and again as the library today. Between 1976 and 2000, it was home for the Provincetown Heritage Museum. An exhibit remnant, ensconced on the second floor, the half-scale model of the 1907 Lipton's Cup winner, *Rosa Dorothea*, sailing ship happily remaining; since 2005, it has been the prideful centerpiece of today's Provincetown Library. This ya gotta see!

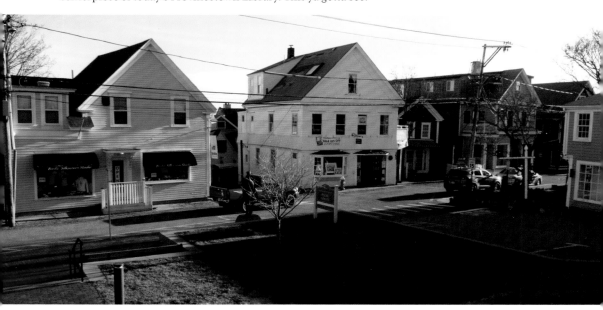

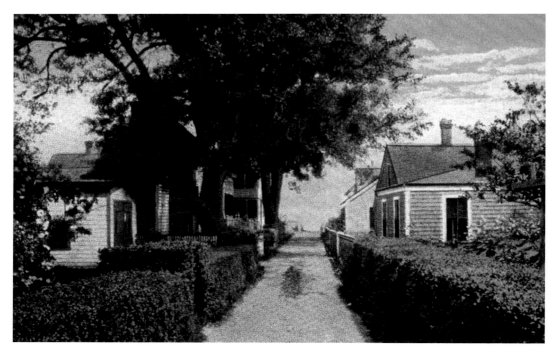

ATKINS LANE FROM BRADFORD: Strolling Atkins Lane down to the beach from Bradford in 1916 captured in a postcard. A century later, it is just as quaint and the beach is in sight—greeting your neighbors along the way is a given. There were several prominent "Atkins" in P'town—one was Frank Atkins, who had the first horse-drawn "accommodation wagon" (tourist bus), *c.* 1896, and the other was wealthy whaler Capt. John Atkins.

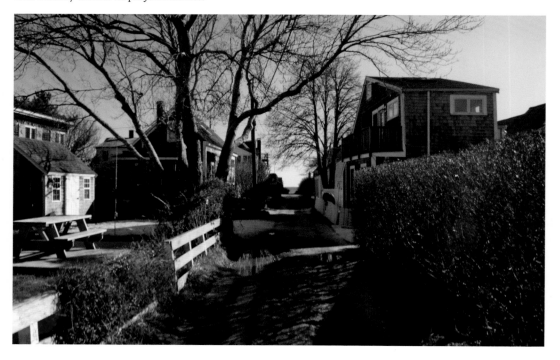

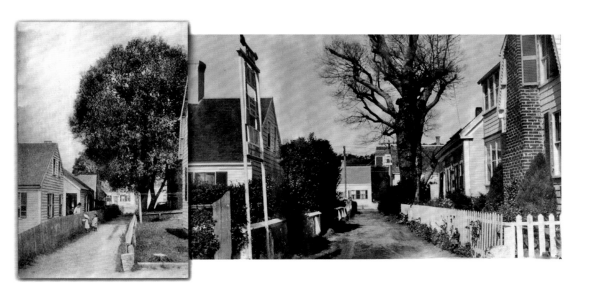

ATKINS LANE FROM COMMERCIAL: Far on the East End is a little lane known as "Atkins," seen here through time with another visual tale of the tree, 1905, 1939, and today, now firewood. Atkins Lane leads across Commercial and "path" its way a few yards to the beach. Although in the '30s (as seen above) there was a rather large directional sign pointing up to Bradford, the twenty-first-century finds "Atkins Anonymous" without a sign in sight.

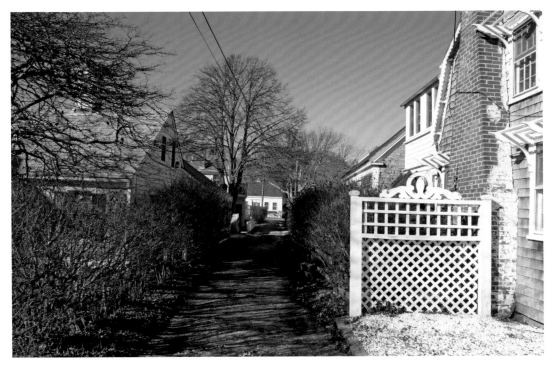

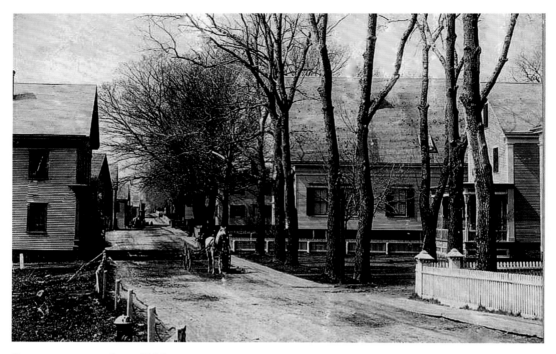

COMMERCIAL AND COOK 1888: Commercial Street. Just west of Cook Street, was a dirt road with wooden sidewalks in 1888. Unpaved roads were normal for the time and very practical, accommodating horse's "fresh tracks" and other road remnants—shown by this rig making its way on the East End. Below: the gray house on the left was the home of Admiral MacMillian, a prep-school days' confidant of Cole Porter and celebrated Provincetown wharf honoree as the North Pole explorer accompanying Admiral Peary.

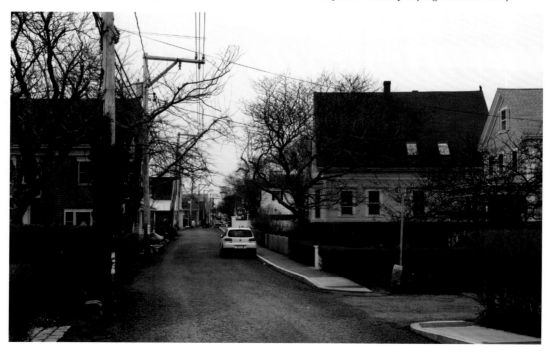

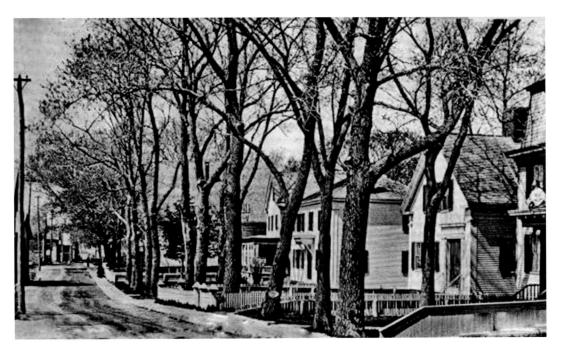

FIGUREHEAD HOUSE: Further east on Commercial at Cook Street was the 1867 home of the whaling fleet owner Captain Henry Cook and the figurehead, seen above on the extreme right in 1900. She was affixed to his home after finding her afloat in the Indian Ocean, lost from her unknown vessel. Today, she has inspired several other figureheads attached to P'town homes, but she is the original and has remained for more than a century and a half now, fulfilling her new role of guarding her condos while continuing her ceaseless gaze out into the bay for her ship to come in—don't we all!

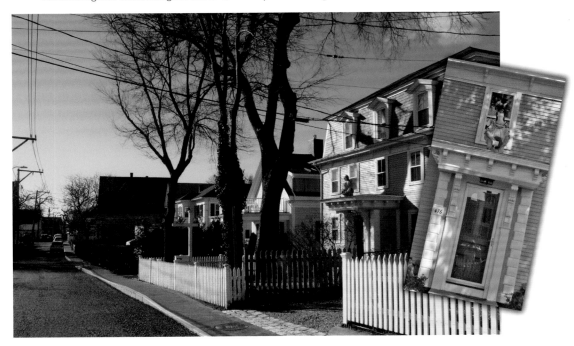

HOPKIN'S HOUSE: From the glass plate collection of Paul Koch of Nickerson & Smith, Rosenthal Photographers, *c.* 1898. At the corner of Tremont and Cottage, the Hopkins family, seen gathered above, were longtime residences of Provincetown from the 1800s and that of the Cape from the 1600s. The family was known as earning a livelihood from the sea, with some meeting an unfortunate briny fate, while other members became well known for their expertise in law.

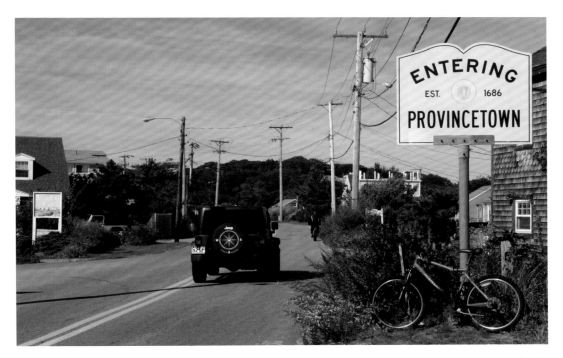

ENTERING PROVINCETOWN: A thrill, a cheer—all are welcomed to enjoy the adventure that is Provincetown. It is not unusual while leaning on a deck railing admiring a harbor sunset to overhear in casual conversation, "We are blessed to be here!" Below: from "My Grandfather's Provincetown" blog, the 1966 photo and remembrance courtesy Manuela Bonnie Oppen Jordan: "This sign greeted us every spring on our annual trek back home from Florida."

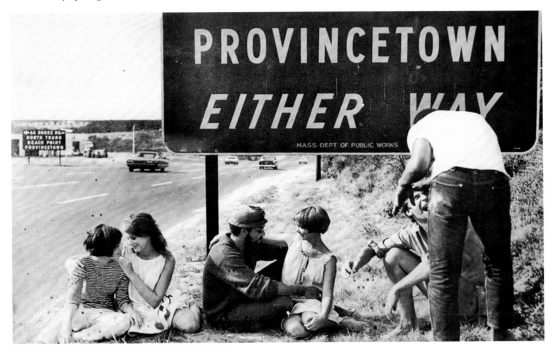

ACKNOWLEDGMENTS

Excellent tools for time travel of any community are the yellowed photographs found in old photo albums and dog-eared shoe boxes. In the case of Provincetown, there is a treasure trove of images from the Provincetown History Project in the collections of Ross Moffett, John R. Smith, and Carl Van Vechten. But the premier album has to be that of Althea Boxell, who assembled a P'town scrapbook of her own photos and the postcards from the Cape Cod Postcards, The Advocate Postcards, and Nickerson collections, and the oddest newspaper clippings from over most of the twentieth century. The scrapbooks were then retrieved for archiving by the noted local artist John Dowd and gifted to the history project.

Aside from resident photographers recording their daily lives, civic events of the day, parades, dedications, and visiting presidents, there are additionally private collections, the recollections, and images of so many P'towners via Salvador Vasques' blog-par excellence "My Grandfather's Provincetown" and Eugene N. Fedorko and his "1930s in Provincetown" blog; some of their contributors are Lisa Jean, Karen Lema Edwards, Frank Henson, Alan Gallant, James Husson-Cote', Dan Mc Keon, and Craig Robinson. Steven Borkowski, of the Pilgrim Monument and Provincetown Museum, was a great help in matching photos on timelines, while Lynn C. Van Dine's book *The Search for Peter Hunt* assisted those gaps. Gracious thanks to the remembrances of P'towners on the street and to Todd Westrick welcoming *Provincetown III* into his Hans Hoffman home.

The contemporary images, except where noted, are the work of local author/photo-artist Frank Muzzy, a "wash-a-shore," whose vacation home is now his main residence. The Library of Congress and Provincetown's own library, with the help of Lead Librarian Nan Cinnater and Ann Cartwright in archives, provided a wealth of images and written history. A good companion book for more info is David Dunlap's *Building Provincetown*. Tech-gratitude-plus to Rolando Vasquez and occasional tech access from Curtis and Sven, with additional thanks for the encouragement of the Provincetown community, Gordon Miller, with just the right glass of wine on the beach, Jeff Peters of East End Books, Fermin and Jay, and that of Armistead Maulpin sharing our tales. While appreciation to artist James Fredrick for the back cover author-image, included is the support of Arcadia's Dani McGrath, and Fonthill Media's Jamie Sutton, Alan Sutton, and George Kalchev.

I dedicate this work to Ameda Lambert Muzzy, an extraordinary woman, actress, writer, businesswoman, confidante, supporter of all things, and mother. *Je t'aime.*

"Silhouettes at Sunset": For my bonfire gang and watching sunsets at Herring Cove.